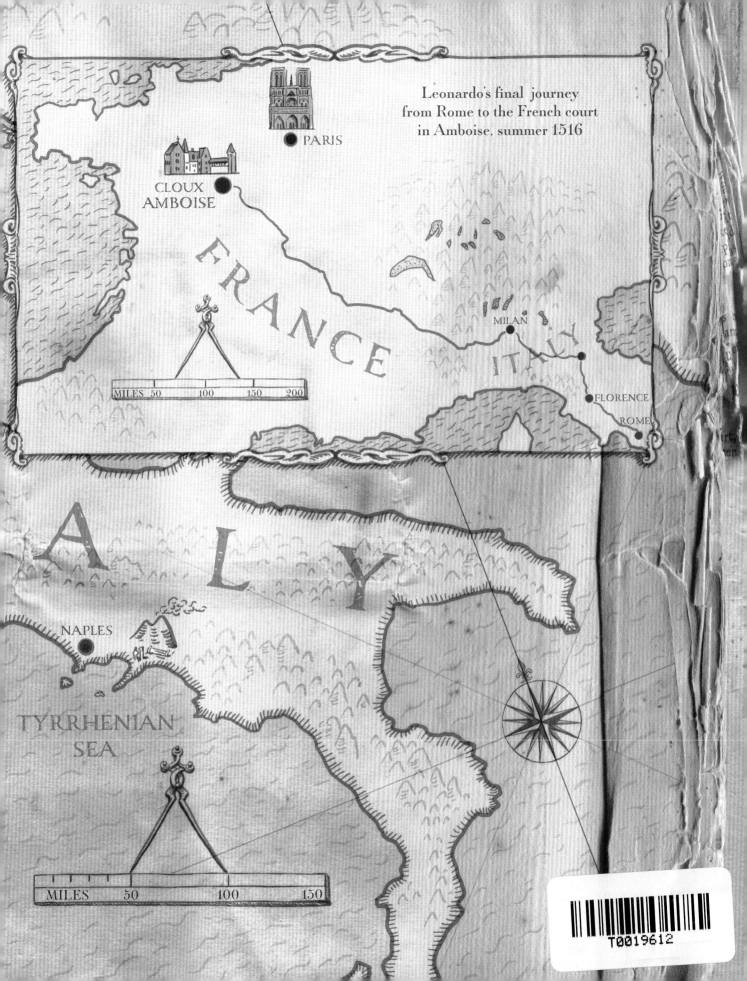

Leonardo's final journey
from Rome to the French court
in Amboise, summer 1516

PARIS

CLOUX
AMBOISE

FRANCE

MILAN

ITALY

FLORENCE

ROME

MILES 50 100 150 200

ITALY

NAPLES

TYRRHENIAN
SEA

MILES 50 100 150

A portrait of LEONARDO

The life and times of Leonardo da Vinci — a literary picture book

DONOVAN BIXLEY

upstart press

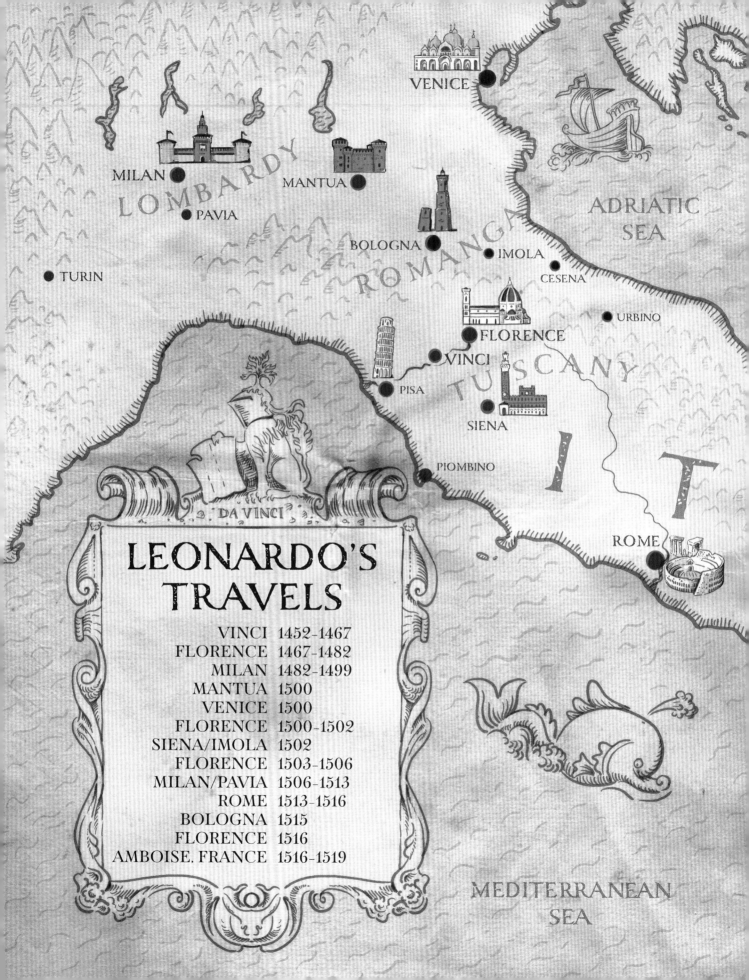

VENICE

MILAN

LOMBARDY

MANTUA

PAVIA

ADRIATIC
SEA

TURIN

BOLOGNA

IMOLA

ROMANGA

CESENA

URBINO

FLORENCE

PISA

VINCI

TUSCANY

SIENA

PIOMBINO

IT

DA VINCI

ROME

LEONARDO'S TRAVELS

VINCI	1452-1467
FLORENCE	1467-1482
MILAN	1482-1499
MANTUA	1500
VENICE	1500
FLORENCE	1500-1502
SIENA/IMOLA	1502
FLORENCE	1503-1506
MILAN/PAVIA	1506-1513
ROME	1513-1516
BOLOGNA	1515
FLORENCE	1516
AMBOISE, FRANCE	1516-1519

MEDITERRANEAN
SEA

Leonardo da Vinci
is a name inseparable from genius …

but don't let that put you off! Biff those stubborn old impressions you have of a drab smock-wearing Renaissance Gandalf. No, Leonardo was always the coolest guy in the room. He was ridiculously famous in his lifetime, and the last 500 years have only confirmed his place as one of the most universally admired people in history.

Leonardo's homeland overflows with some of the world's greatest artists, engineers, scientists and architects, and still Leonardo is considered above them all. He's the archetype we think of when we imagine human brilliance, yet Leonardo certainly wasn't that cliché image of the bearded old man, shuffling about in robes, surrounded by his thousands of manuscripts. Leonardo was flamboyant and gregarious, mucking in and getting hands-on experience out there in the world.

It's impossible to give a shortened version of the life of Leonardo. His output is so vast, and his interests and inventions so many, that this entire book can't possibly contain Leonardo's full awesomeness. Leonardo's artworks and a dry list of his doings are easy enough to obtain online, yet this volume hopes to show off his personality alongside some of those wow moments in his life — revealing that he was far more than a one-dimensional character. He was a curious boy, a sensitive teen, an arrogant upstart, a fantastical day-dreamer, and a bloody-minded scientist who was defiant of authority and the status quo. Above all, he was a fiercely independent personality.

One factor that makes Leonardo's achievements still resound with us over so many centuries is his openness to new ideas in his quest for

answers. He was not locked into predetermined ways of thinking, and this allowed him to combine art, science, engineering, philosophy and architecture without the strict boundaries that separate these disciplines today.

It's difficult to appreciate just how strong-willed Leonardo must have been. He spent his life forging ahead with innovative ideas in the face of constant criticism and scepticism. His studies were not just contrary to the traditional way of thinking, but in a world emerging from the Dark Ages, some of Leonardo's ideas were outright heretical.

But what makes Leonardo ceaselessly fascinating is that he is the quintessential example of that obscure nobody who made it big. He wasn't rich, or privileged, or sent off for special education. Leonardo was a bastard child from an insignificant village, yet he rose to become one of the greatest thinkers of all time. When all the warmongers and powerful rulers have been forgotten, the artist Leonardo da Vinci will be remembered.

How could you describe
this heart in words without
filling a whole book?

LEONARDO

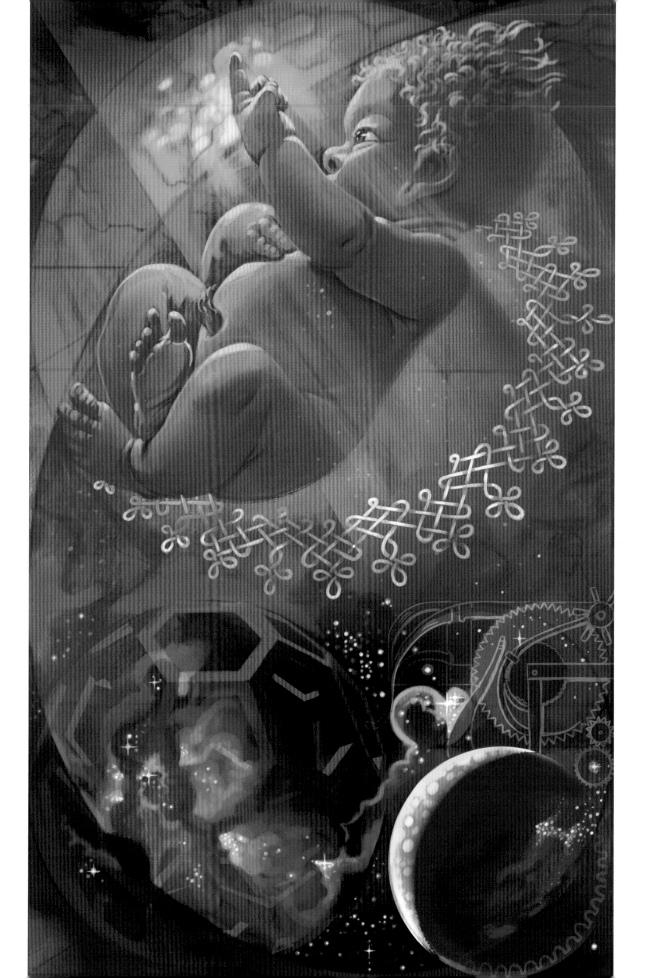

He was like a man who awoke too early in the darkness, while the others were all still asleep.

SIGMUND FREUD ON LEONARDO DA VINCI

Europe was a dark and superstitious place when Leonardo came into the world. It was 10.30 at night, not far from a sleepy little village in central Italy. His mother, Caterina, was a sixteen-year-old country girl. His father, Ser Piero di Antonio da Vinci, was an up-and-coming twenty-five-year-old notary, who was already engaged to a wealthy fiancée in the nearby city of Florence. Leonardo was illegitimate, but not unloved. Grandfather Antonio proudly recorded the arrival of his first grandchild on 15 April 1452, and the baby had ten godparents.

Europe was just waking up from the Dark Ages, but a rebirth of art and science was taking place, and the heart of this Renaissance was happening not far from Leonardo's home town of Vinci. This unremarkable little village would give its name to Leonardo … and this newborn baby would go on to make it one of the most famous names in history.

The breathing of the mother, and the beating of her heart, work in the life of the child.

LEONARDO

Leonardo's mother soon married a local kiln worker known as Accattabriga, a common nickname among ex-soldiers meaning 'bully'. Very little is known of Leonardo's life with his mother and stepfather, however Leo's new family soon included two little sisters, with another three siblings to follow over the decade. His father was not as fortunate in producing heirs, and it would be 1476, when Leo was twenty-four, before Ser Piero had a legitimate child with his third wife.

His father may have been a rich city notary, yet in that family Leo was a bastard — although a lucky bastard in many respects. As an outsider in both households he had no obligations to take on the family trade and get an office job, as would have been expected from a legitimate eldest son. Instead, Leonardo was free to follow his own path. It's a trait of his personality that he cultivated throughout his life, and he avoided obligation whenever he could. Although he was christened Leonardo di ser Piero da Vinci, he is not remembered as Piero's son, but simply Leonardo da Vinci — Leonardo from Vinci*.

* Vinci takes its name from the shoots of local river willows used in basket weaving. Leonardo loved the intricately woven knot-work patterns, as well as visual puns, and he used both of these throughout his artworks, such as his 'academy' logo, re-created on page 7.

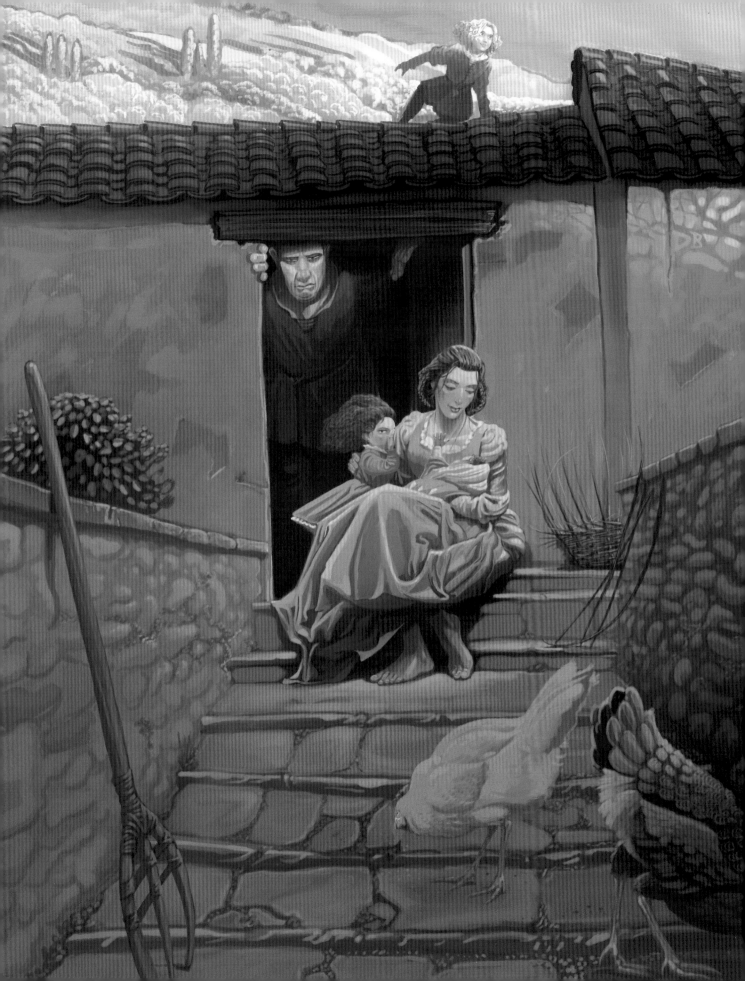

The artist should live
a life of complete harmony
with the natural world.

LEONARDO

From the age of five, Leonardo was living in the tiny settlement of Anchiano, just up the hill from the town of Vinci, in his grandfather's house (which you can still visit today). Here, he hung out with his favourite rustic rellie, Uncle Francesco, his father's younger sibling, who was a brotherly fifteen years older than Leo.

Leonardo was a typical small-town boy, and in many ways he remained that country boy at heart his whole life. Although he would grow up to rub shoulders with the most powerful rulers of his time and experience great luxuries, he was equally content with the simple life he'd grown up with.

Every child today can connect with Leonardo's endless curiosity and his childlike wonder at the world … that most prodding of questions, 'But why?' Leonardo never outgrew those simple questions about the great phenomena that surround us. Why is the sky blue? How do ripples intersect without breaking? And what is so fascinating about a woodpecker's tongue?

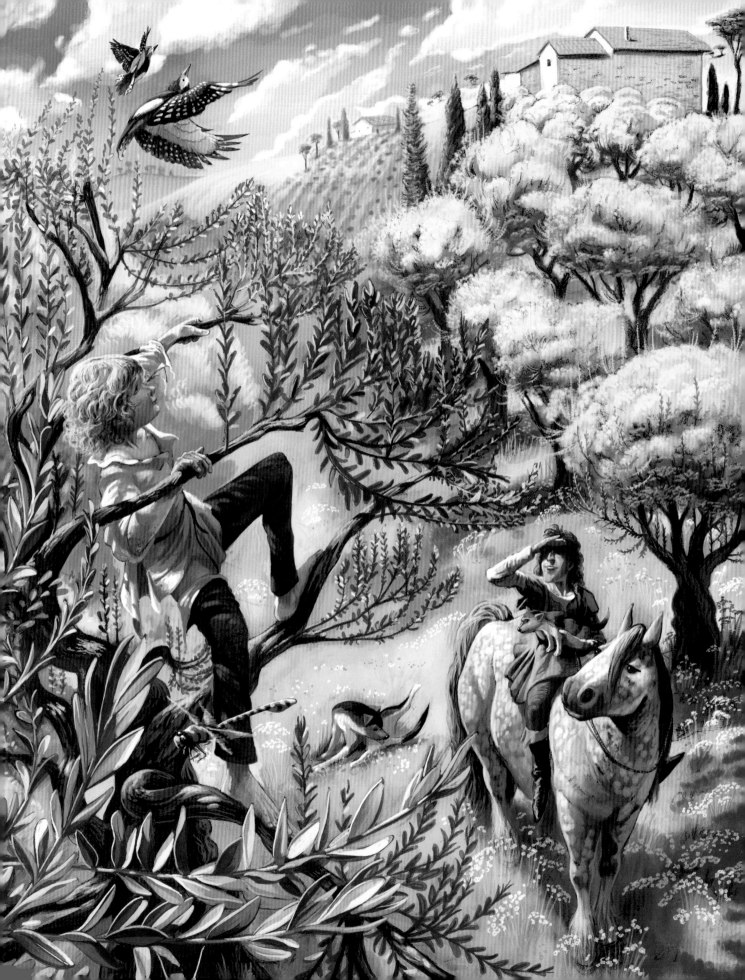

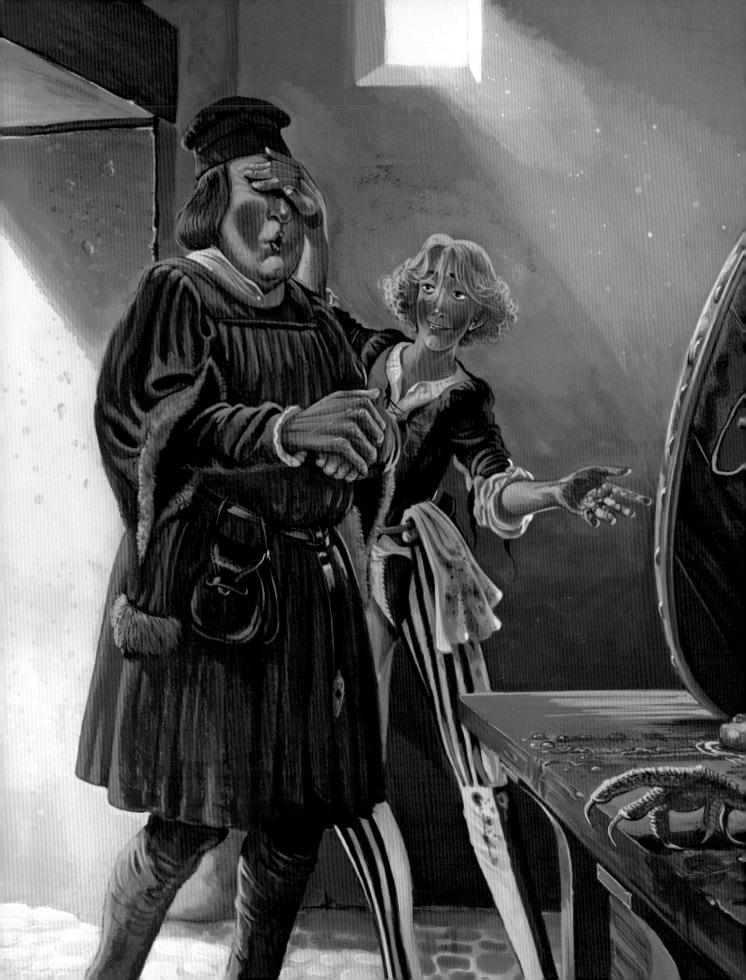

If you wish to make a dragon —

take for its head that of a mastiff,

for its eyes those of a cat,

for its ears those of a porcupine,

for its nose that of a greyhound,

with eyebrows of a lion,

the temples of an old cock

and the neck of a water-tortoise.

LEONARDO

It's impossible to know when Leonardo's artistic talent began to show itself, but it was certainly obvious by his teens. According to Renaissance biographer Giorgio Vasari* (writing almost 100 years later), Leonardo's father was asked by a local peasant to take a round shield to Florence and have some great artist paint a fierce monster on it. Leonardo's abilities must have been clearly evident because instead, Ser Piero took the shield to his son.

Leonardo painted a lifelike monster, all the more amazing because he had based it on real lizards and animals. The teenager pranked his father by setting up the finished shield dramatically lit in a darkened room, before asking Dad to come and look.

Piero's response must have been priceless. He definitely thought his son's artwork was, because he took the shield to Florence and sold it for a fortune before purchasing a bargain-basement replacement for the peasant. Leonardo's shield was so impressive that it eventually came into the collection of Florence's powerful Medici family.

* Giorgio Vasari was a painter, sculptor and writer who invented the word 'Renaissance', meaning rebirth. He compiled the first-ever artist biography with his great work, *Lives of the Most Excellent Painters, Sculptors, and Architects*. It was first published in 1550, thirty-one years after Leonardo's death, and is still in print.

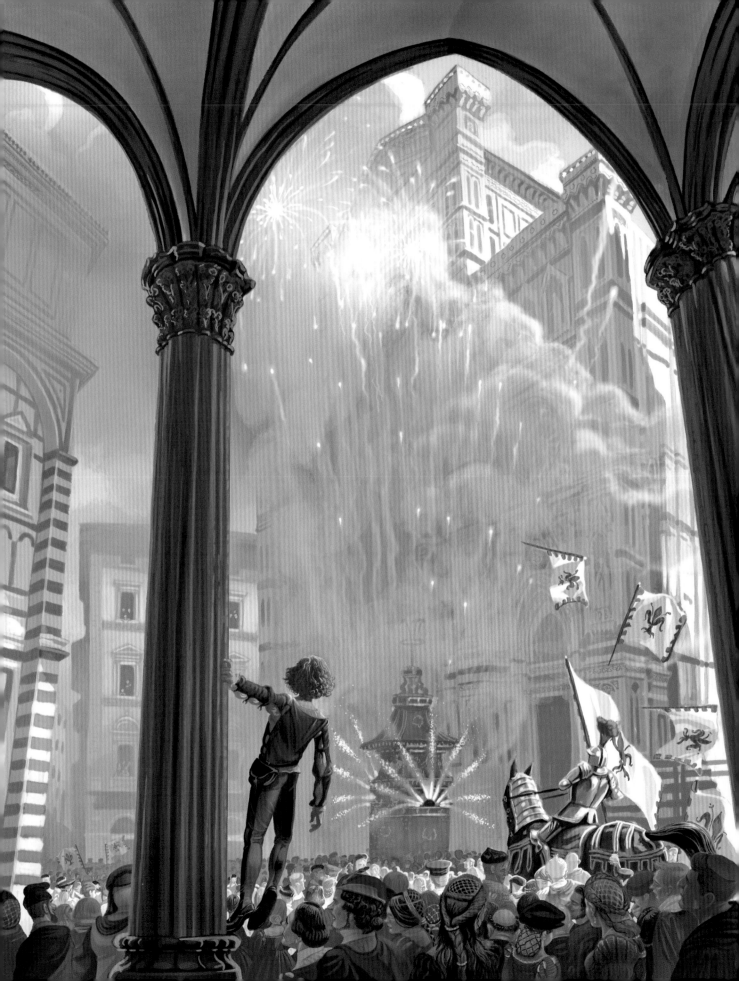

In Florence many visitors congregate, and there when they see its beautiful and stately works of art they form an impression that the city must have worthy inhabitants.

LEONARDO

The closest centre to Leonardo's home town just happened to be the most exciting, vibrant, artistic city in the world. There was no better place for young Leo to go than Florence, and he arrived at exactly the right time. The city was governed by the Medici family, who, in three generations, had risen from wool traders to the most powerful bankers in Europe. Patronage of artists was at its height, and these common-born rulers wanted to show their power and wealth through the arts.

Florence was the perfect place to nurture Leonardo's raw creativity. Here, ambitious architecture towered over elegantly paved streets, and extravagant pageants were put on display alongside incredible sculptures and stately public artworks. Throughout his life, Leonardo would go on to work across all of these fields.

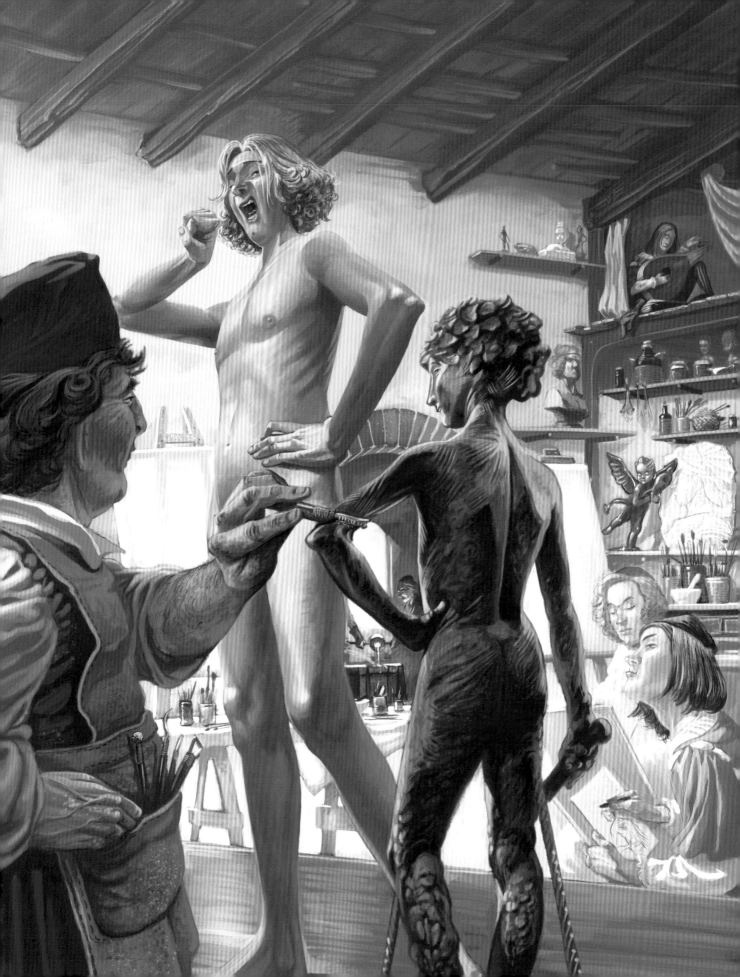

Let your work be such that after your death you become an image of immortality.

LEONARDO

Under the rule of the Medici family, Florence became the birthplace of the Renaissance. During a one-hundred-year period, some of the greatest minds flocked to the city. The architect Brunelleschi built the dome of the Florence cathedral, the greatest architectural achievement of the era (and he just happened to invent perspective drawing along the way — a technique which gave two-dimensional paintings a sense of realistic depth and space). Sculptors Donatello and Ghiberti created their great masterpieces alongside painters like Lippi and his brilliant student, Botticelli, who invented a whole new style of fantasy art. Into this creative melting pot came Leonardo.

Leonardo's father got his son an apprenticeship at the bottega (or workshop) of master craftsman Andrea del Verrocchio. Here, Leonardo studied drawing, painting, sculpture, design and architecture. The bottega produced work for many purposes, from pageants and altarpieces to murals and sculptures. At the time of Leonardo's arrival, Verrocchio had just been commissioned to create a sculpture of a youthful King David, a popular symbol of Florence's small size and grand ambitions. Teenage Leonardo was immortalised in Verrocchio's artwork* — a model student for his master.

* Verrocchio would have made an initial sketch of the 125-cm tall figure in clay, before casting the final version in bronze. The sculpture is now in the Museo Nazionale del Bargello, Florence.

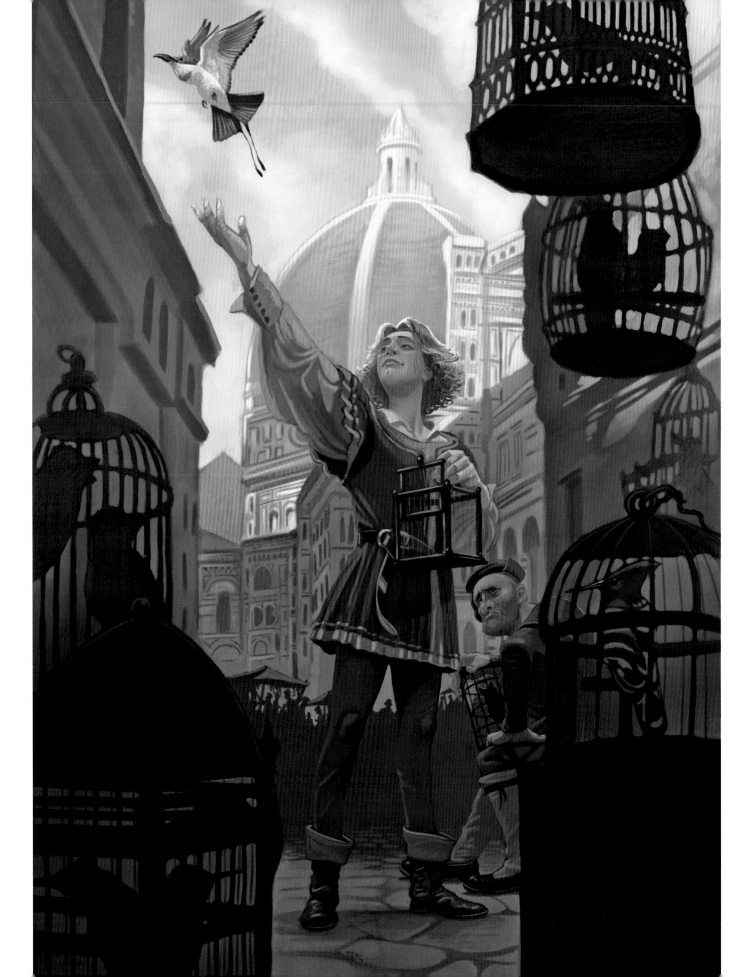

The chief gift
of nature is liberty.

LEONARDO

Leonardo was certainly not your usual fifteenth-century chap. A fellow Florentine returning from India wrote that Indians ate only vegetables and did no harm to animals, 'like our Leonardo'. Leonardo deplored man's cruelty to animals, and many of his later works involved machines that were designed to spare beasts of burden. In one notebook he even admonishes humans for tearing acorns away from their mother oak.

Leonardo's early biographers tell a touching story of the artist purchasing birds at the market. The street sellers must have thought him even more unusual when the young man set the birds free. But Leo's true unusual ability was his legendary 'quickness of eye'. As well as giving the birds their liberty, he was observing the movement of their wings. Scholars have long marvelled at Leonardo's ability to draw forms in motion. On paper he was able to capture flowing water, the individual movements of a dragonfly's wings, and galloping horses like no artist before him.

I never weary of being useful.

LEONARDO

Leonardo had only been in Verrocchio's studio for a couple of years when his master was awarded the task of putting the finishing touches on Florence's magnificent cathedral. This commission included constructing a huge copper orb, and on 27 May 1471 it was hoisted into place, on the very top of the Duomo. Nineteen-year-old Leonardo would have learnt a tremendous amount from the project, which involved considerable engineering experience and geometric precision in casting and gilding the curved copper panels — years later, Leonardo wrote that these were soldered together to form the sphere using a beam of light from concave mirrors.

It was the height of technical innovation and Verrocchio's star pupil showed that he was quick and willing to learn … and more! Leonardo made detailed drawings of the rotating cranes and hoists, and the ingenious reversible gears that had been invented by Filippo Brunelleschi to construct the Duomo's spectacular dome thirty-five years earlier. These original devices, as well as new machines, were used to hoist the two-ton sphere into place. Cafés and wine sellers set up shop in the precarious scaffolding to save workers lost hours climbing up and down for meals. The entire project was a major engineering feat which would spur Leonardo's lifelong fascination with machines.

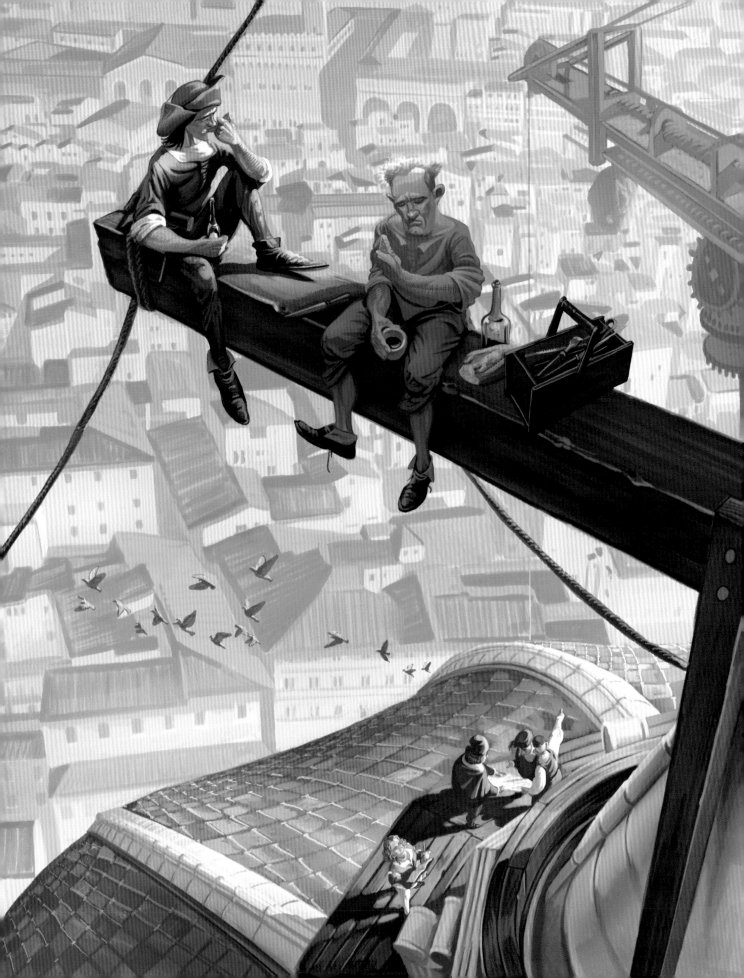

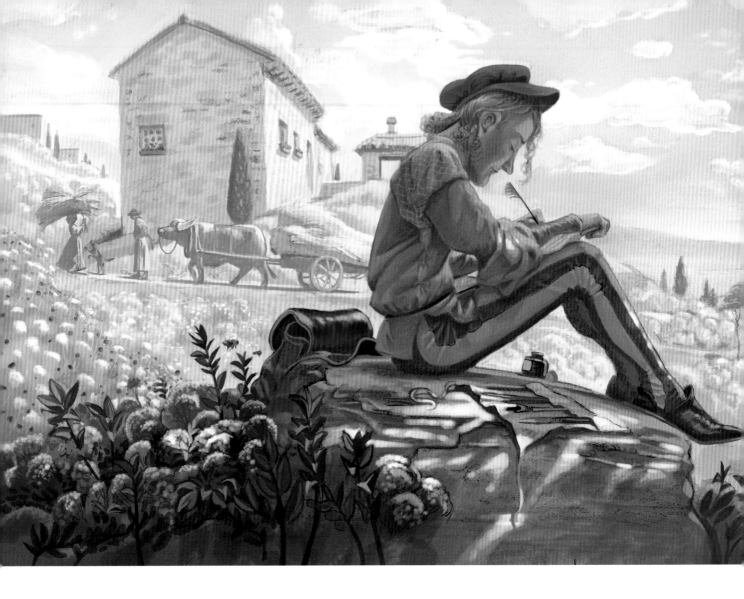

What induces you, oh man, to depart from your home in town, to leave parents and friends, and go to the countryside over mountains and valleys, if it is not for the beauty of the world of nature?

LEONARDO

While his father had moved to the city, the simple rural life chosen by Uncle Francesco had a lasting effect on Leonardo. During his early years studying and working in Florence, Leo would often return to the hills of his childhood. His earliest surviving artwork is a drawing of the Arno Valley looking down from the hills of Vinci and Anchiano, sketched when Leonardo was twenty-one. Uncle Francesco would go on to leave Leonardo his entire inheritance of land around Vinci.

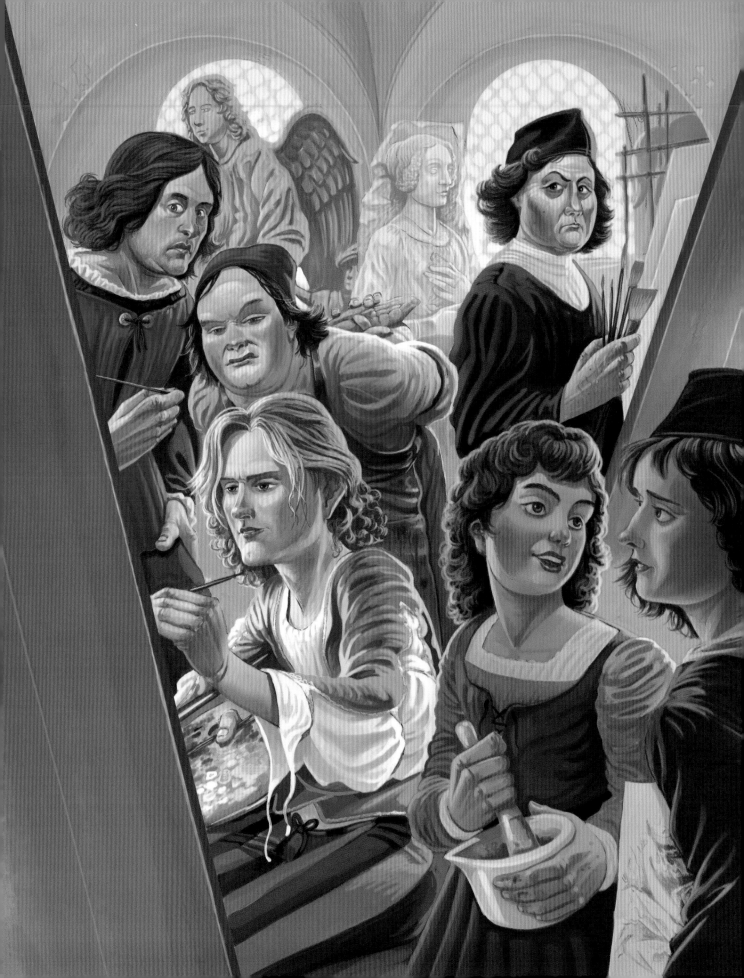

Poor is the pupil who does not surpass his master.

LEONARDO

Of all Verrocchio's students, Leo was the most precocious talent. He became an expert sculptor in clay and metal, as well as designing banners and mechanics for festival pageants. But Leonardo really shone as a painter.

His ever-questing nature is evident in his use of the new Northern European technique of oil painting — a method not used or taught by his master. Oils allowed Leonardo to create a new style of painting, experimenting slowly with many thin layers smoothed in places with his fingertips. With oil paints Leo developed a softness and depth of smoky moulding, or *sfumato*, that would become his trademark.

During this period, Verrocchio was working on a major painting, *The Baptism of Christ*, and all who saw it were struck by the artwork — not for Verrocchio's main figures, but for the kneeling angel in the bottom left corner. This radiant figure, with flowing ringlets of golden hair, was painted not by the master but by his star apprentice, still in his early twenties. Legend has it Verrocchio was so awed by Leonardo's artistry that after completing *The Baptism of Christ* he laid down his brushes for good.

Nothing is so much to be feared as a bad reputation caused by vices.

LEONARDO

Leonardo was always a bit of an outsider. He was illegitimate, he was a country yokel in the city, he was a left-hander … and he was also gay. Homosexuality was not such an uncommon thing in Florence, and other gay artists included Donatello, Botticelli and Michelangelo. The city was so renowned for its gay men that the term 'Florenzer' became common slang for queer men in other parts of Europe.

In the 1470s, homosexual activity was a vice punishable by being burnt at the stake. Thankfully this was almost never enforced, because when Leonardo was twenty-four he was twice accused of homosexual indecency. The young artist, along with several of his friends, was arrested by the Officers of the Night and briefly detained in prison. The group were released when the anonymous accuser never came forward to press the charges, and it is around this time that Leonardo drew a design for one of his first machines — a device for breaking men out of prison.

In subsequent centuries, Leonardo's sexuality was hushed up by historical prudes, who claimed that his genius simply drove out any sensual passions to take a wife. Yet Leonardo writes, with hilarious attention to detail, how the penis does not always function when you desire it and vice versa — when you least desire it, it has a mind of its own.

I tried to see whether I could discover anything inside, but the darkness within prevented that. Suddenly there arose in me two contrary emotions, fear and desire — fear of the threatening dark cave, desire to see whether there were any marvellous thing within.

LEONARDO

Leonardo loved to explore natural phenomena, and wandering the Tuscan hills one day he came across a cave which had a dramatic effect on the young artist. The entire experience stands as a perfect metaphor of Renaissance thinking. The superstitious fear of the dark is matched by Leonardo's unquenchable desire to explore the unknown …

Oh time, swift despoiler of all things, how many kings, how many nations hast thou undone, and how many changes of states and of circumstances have happened since this wondrous fish perished?

LEONARDO

In the cave, Leonardo discovered the wondrous fossil of a whale. His imagination vividly brings the bones to life. He can picture the creature thrashing its tail in the ocean and he concludes that aeons have passed. It was a momentous thought — to question the standard religious doctrine of the time, which postulated that the earth was only several thousand years old. The extraordinary result is that Leonardo begins pondering what geological process has placed this whale in the mountains, so far from the sea. It was a question that he would come back to again and again whilst poking around at the fossils of crabs and shells across Italy's mountain ranges.

Look into the stains of walls, or ashes of a fire, or clouds, or mud or like places, in which, if you consider them well you may find really marvellous ideas.

LEONARDO

Leonardo's paintings are peppered with visual puns and hidden symbols, which were popular among Renaissance artists. In his advice to budding painters, Leonardo encourages them to stir their imagination by looking deep into the natural world around them. Here, they may discover mythical beasts, battling demons and other nightmarish optical illusions worthy of Leonardo's Northern European contemporary, Hieronymus Bosch. Leonardo's own imagination was far more inspired by fantasy than his famous paintings suggest. In one delightful drawing, featuring cats frolicking across the page, Leonardo has included a baby dragon, coiled amongst its feline friends.

Many vain pleasures are enjoyed, both by the mind … and by the body, in taking those pleasures.

LEONARDO

Through Leonardo's legacy of notebooks we are presented with so many faded sketches on greying paper that it's easy to imagine his world as brown. Nothing could be further from the truth. His famous paintings may be muddy and unfinished, or overpainted with centuries of restoration and cracked varnish, but under the murk Leonardo's love of colourful decoration is clearly demonstrated. Close inspection reveals fine details of embroidered fabrics, elegant stitching and jewellery, matched with ornate weapons and armour.

Leonardo's contemporaries record his personal love of fashion, and he was renowned for wearing short tunics when long tunics were favoured by everyone else. Leonardo's notebooks list a large wardrobe containing multicoloured stockings, rose and scarlet tunics, and sparkling capes with velvet lining and fur trim. His vanity extended to bathing his hands in fresh rose-water and he would have cut a swathe through the city crowds as he swaggered along wearing his blue sunglasses. Leonardo was handsome, gregarious and absolutely fab-u-lous.

I wish to work miracles.

LEONARDO

Filippo Brunelleschi, who had solved the unsolvable problem of constructing the dome of the Florence Duomo, also used his engineering skills to create innovative theatre contraptions. These could fly dozens of cherubs across a stage, or allow an actor to ascend to the heavens. Some of Brunelleschi's devices were still being used during Leonardo's time as an apprentice when he was working on theatrical performances in Verrocchio's studio.

Inspired by Brunelleschi, Leonardo's earliest drawing of a flying machine is a spectacular bat-wing glider, dating from his time in Florence in the late 1470s. Many of Leonardo's early attempts at designing flying machines are totally impractical and were actually intended as theatrical props. However, the fascinating aspect of Leonardo's first flying machine is a small scribble on the back of the drawing where the budding inventor has made observations on the descent of gliding birds. Leonardo was formulating ambitious dreams of working a miracle worthy of Icarus, and turning theatrical trickery into reality.

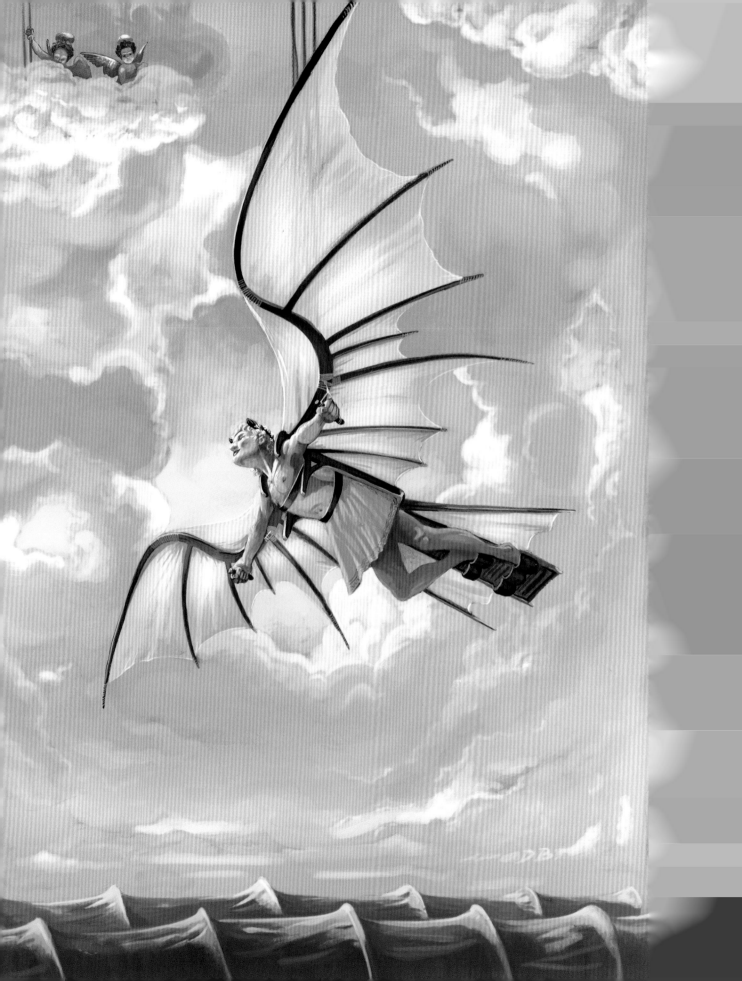

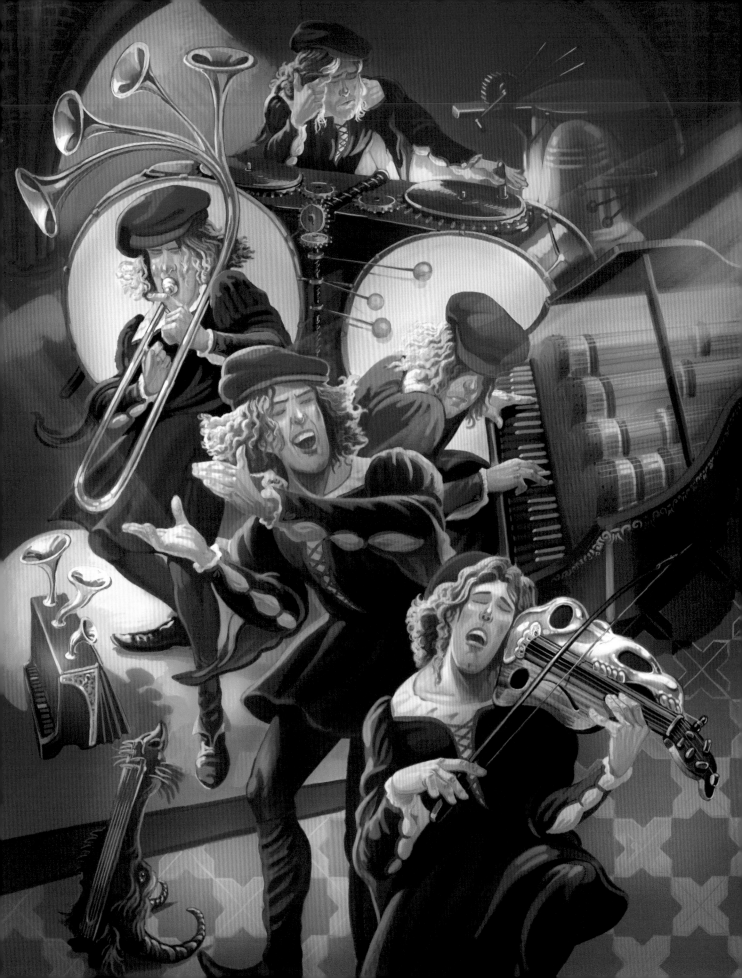

I will make unending sounds from all sorts of instruments.

LEONARDO

Music and art went hand in hand in the artisan workshops of Florence. In Verrocchio's bottega Leonardo learnt to play a variety of instruments, as well as read and write musical notation. He counted music second among the arts — after painting, of course. It's intriguing to imagine Leonardo as an extrovert performer revelling in the limelight, and his early biographers unanimously agree that he was a beautiful singer and a master of the lira da braccio, an early form of viola. This was no idle boast, as Leonardo taught music to Atalante Migliorotti, who would go on to become a famous opera singer and instrument maker*.

But Leonardo's ever-curious mind was not content with merely playing music. During his life he went on to invent bizarre horns, chiming bells, a viola organ, automatic keyboards and drum machines which could be programmed to beat out complicated rhythms — enough instruments to form his own one-man band! His most famous musical creation was a lira da braccio sculpted from silver in the shape of a horse's skull. Leonardo's renown as a performer on this fantastical fiddle would bring him to the attention of one of Europe's most powerful rulers.

* Leonardo's painting *Portrait of a Musician* is thought to be of his friend Atalante.

Take a flat mirror and often look
at your work within it. It will appear to be
by the hand of some other master. A lack of
harmony or proportion is more readily seen.

LEONARDO

Much has been made of Leonardo's 'secret' mirror writing. His thousands of pages of notebooks are written primarily in his beautiful distinctive script, running backwards across the page from right to left. However, this had nothing to do with keeping secrets. Leonardo's mirror writing was simply a natural technique for a left-handed artist. There was even a handwriting instruction book from the period which demonstrated the technique of mirror writing for left-handers. Leonardo wrote and drew right to left, so as not to smudge the wet ink or dusty charcoal with his hand. As a child from a small village he did not go to school where he would have been made to use his right hand.

There were certainly times when Leonardo became paranoid about plagiarism and wished to keep his ideas hidden, and in these cases he used simple codes, acronyms and abbreviations. Mirror writing was not a very secretive method when one could simply hold up a mirror to read it — especially as Leonardo encouraged all artists to have a mirror in their studio.

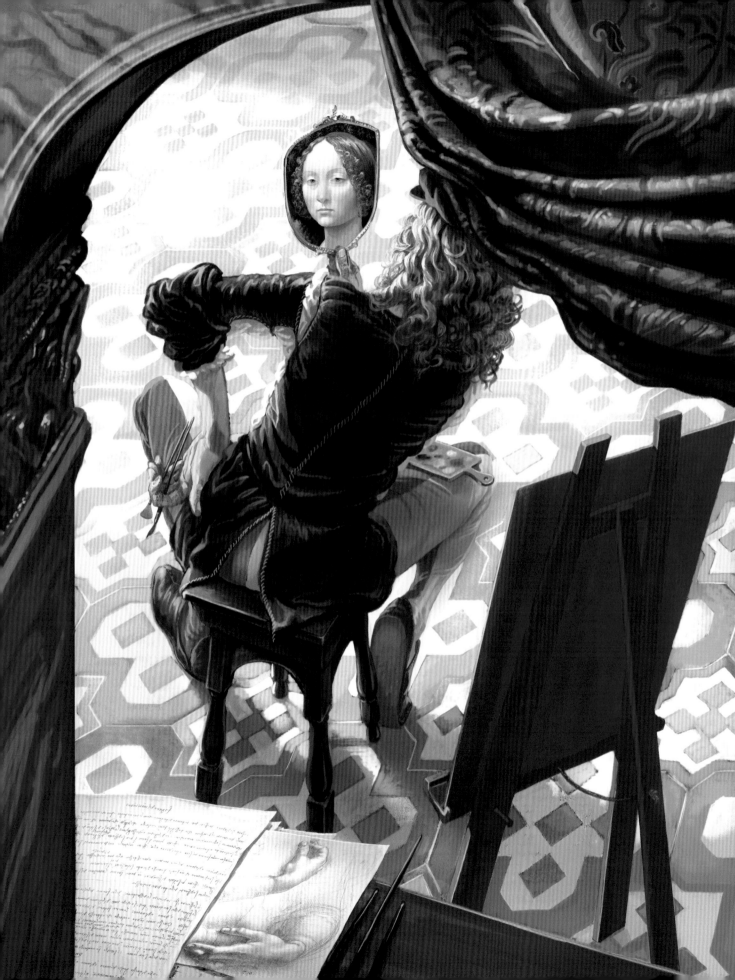

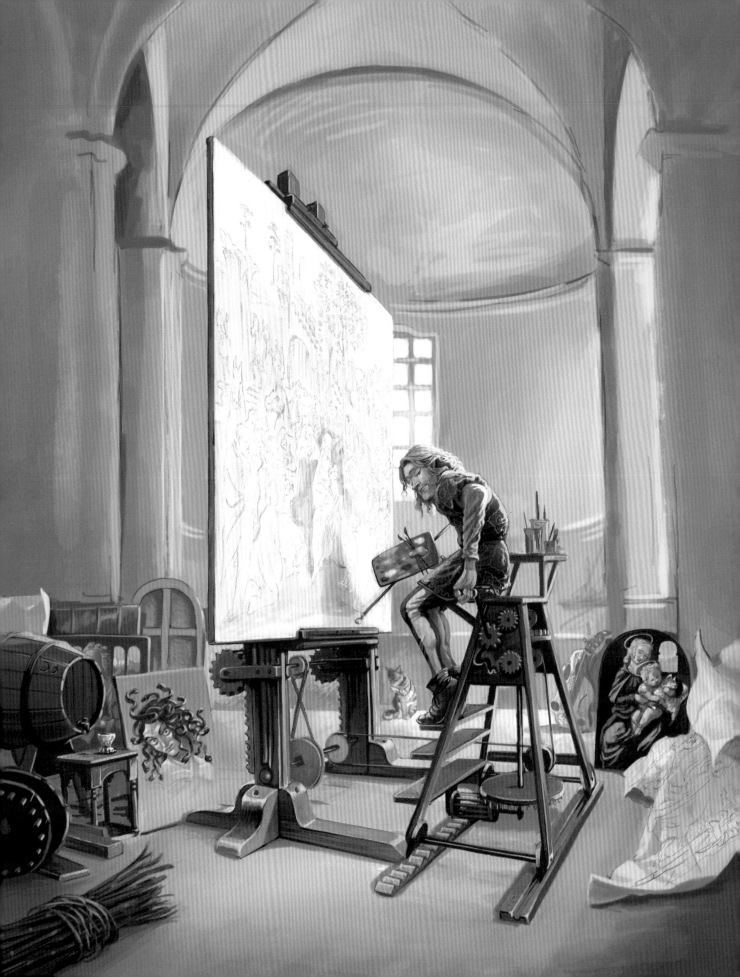

Lying under the quilts will not bring thee to fame.

LEONARDO

Florence was a crowded, highly competitive arts market. Yet, on the back of the work Leonardo had done with Verrocchio as well as two impressive paintings he had completed by himself — *The Annunciation* and a striking portrait of Ginevra de' Benci — he decided to set up on his own*.

Now in his mid-twenties, Leonardo faced the same problems that young start-ups face today — managing long periods between payments and negotiating commissions, no longer in the steady workflow and lodgings of his former master. Leo quickly went into debt, borrowing money which he spent on firewood and a barrel of wine! His standard money-earners were religious paintings: *Madonna and Child with Rose*, *Madonna and Child with Windmill*, *Madonna and Child with Pussycat* — paintings so generic that they can't even be distinguished as works of Leonardo. He did however receive two big commissions, but it seemed that he got mindlessly bored with the weeks and months of painting after the fun of sketching his preparatory studies.

Instead, Leonardo would devise projects to keep himself stimulated, such as creating an easel which moved the painting up and down so that the artist could remain comfortably seated. These diversions saw Leonardo leave two masterpieces unfinished, a trait that would become his trademark. Even unfinished, his *Adoration of the Magi* and *Saint Jerome* were of such innovation that they proclaimed Leo's talent to the world. But Leonardo had grown restless with painting, and with Florence. He was on the lookout for something new.

* This coincided with the birth of his father's first legitimate son in 1476, an event that would push Leonardo out of the immediate family circle, and the security it offered.

When fortune comes grasp her with a firm hand — in front, I tell you, for behind she is bald.

LEONARDO

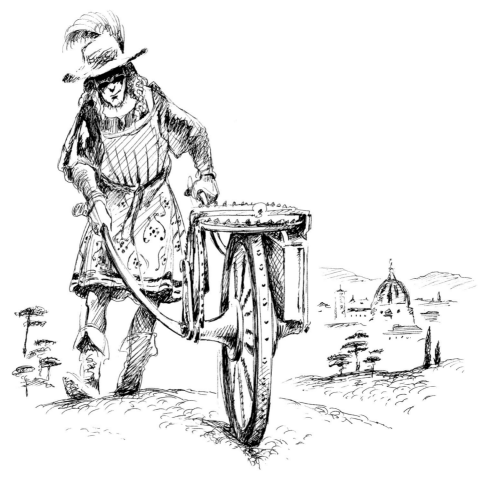

In 1482, Leonardo travelled to Milan as part of a diplomatic delegation. He grabbed the opportunity with both hands and decided to move for the long term. He took with him almost all of his possessions, including the silver lira da braccio he had made in the form of a horse skull, which was to be the delegation's gift to Milan's ruler.

Every outing was a chance for Leonardo to experiment. During the journey he tested an odometer he had devised which dropped a marble into a tray with every turn of the wheel. Leonardo's machine accurately measured the distance from Florence to Milan at 180 miles.

Where Florence was governed by a banking family, Milan was ruled in right royal style by Ludovico Sforza, with a castle, a court and all the trappings — court engineers, court musicians, court entertainers and court artists. With 125,000 people, Milan had three times the population of Florence and Leonardo had great ambitions of a permanent position at Ludovico's castle. Here, Leonardo could get away from his persona as Verrocchio's upstart apprentice, and because Milan was renowned more for its intellectual scholars than its master artists, it was the perfect place for him to make a splash. Milan was flamboyant and showy, and Leonardo da Vinci loved it! Here, he was going to reinvent himself … as Leonardo the Florentine.

The rulers of Florence regularly used their famous artists as diplomatic tools, like royal marriages, to secure bonds of alliance in the region. So it was that Leonardo had come to Milan with a gift of the silver horse-skull lira, when it was actually Leonardo who was the gift.

Leonardo presented to Milan's ruler, Ludovico Sforza, a letter which has since become the artist's most quoted document. The letter shows Leonardo in a mode of supreme youthful arrogance, confidently boasting of great things he has not yet done. He lists fantastical weapons he will design, such as giant crossbows and cannons, armoured tanks, and chariots armed with rotating scythes. He plans new kinds of bridges, ingenious defences and fabulous wonder works of engineering. He claims he will cast the largest bronze sculpture ever made — he really is hoping to invent himself anew as the ultimate court creative. Strangely, for modern audiences, who recognise Leonardo mainly through his paintings, he flippantly finishes his grand boast with a turn of humility …

LUDOVICO SFORZA

Also I can do in painting whatever
may be done, as well as anyone else.

LEONARDO

The perseverance
to invent such things anew
is found in few people.

LEONARDO

Among Leonardo's most famous drawings are his futuristic military contraptions proposed in his letter to Ludovico Sforza — none of which were realised in his lifetime. Yet, it's important not to overlook the many real devices Leonardo invented, engineered and built for various projects. These include hoists and cranes, diggers and looms, machines for minting and beating gold, as well as a water-powered sawmill. His engineering skills were also called upon to expand Milan's system of canals. His most wide-spread invention was the match-lock, a consistent sparking device which operated like a modern flick lighter and was quickly taken up by gun makers across Europe. Leonardo was obsessed with mechanisms and the automation of repetitive tasks to streamline production. Many of his machines are firmly rooted in the ideas of the industrial age, which would come three hundred years later.

My subjects require for their expression not the words of others but experience.

LEONARDO

Leonardo was never offered his dream job as a military engineer for Ludovico Sforza. Instead, he fell back on his primary talent as a painter, joining a collective of artisans, the de Predis brothers, in their Milan workshop.

Leo was the Florentine master, but the brothers had the local contacts and in 1483 Leonardo got his first big commission. In collaboration with the brothers, Leonardo was to embellish an altarpiece — a commission which came with a very tight contract (Leo's reputation for not delivering on time or budget was already legendary). In typical independent bloody-minded style, Leonardo completely ignored the contract's detailed instructions on composition and garish colouring. He required no artistic direction from lawyers! Instead, following his own judgement, Leonardo created an immersive painting, with so much depth, it felt as if the viewer were peering into a real grotto where you could see the Virgin Mary with baby Jesus, John the Baptist and the archangel. *The Virgin of the Rocks* was to become Leonardo's first true masterpiece, taking two years to complete … eighteen months over deadline. Then began the legal battles over the contract.

Eventually Leonardo took his original and sold it to another buyer (this painting is now in the Louvre). A second version (currently in the National Gallery London) was co-painted with the de Predis brothers. But Leonardo was not a man to be harassed by lawyers and there wouldn't be a satisfactory conclusion to *that* saga for another twenty-three years.

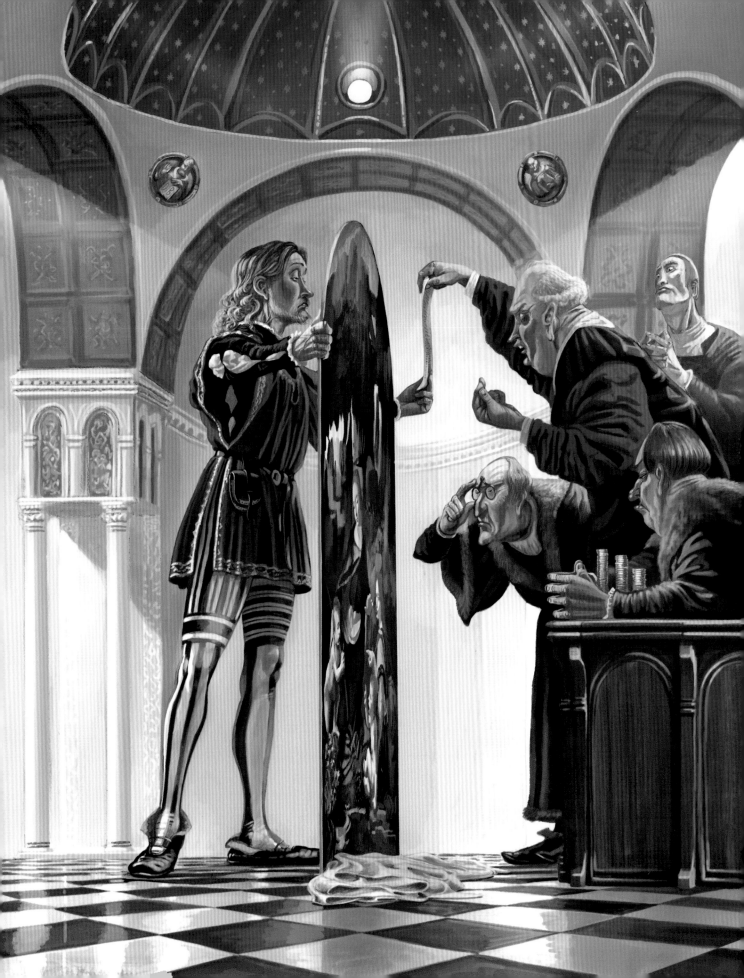

If you understand that
old age has wisdom for its food,
you will so conduct yourself in
youth that your old age will not
lack for nourishment.

LEONARDO

Milan's location in northern Italy drew many talented people across the Alps from France, Germany and the Netherlands, as well as from within Italy. It wasn't long before Leonardo met a kindred spirit, a fellow 'Renaissance man' with similar beginnings in small-town Italy.

Donato Bramante was a genius with a gift for architecture, but he was also a painter, musician, poet and philosopher. Bramante was eight years older than Leonardo, and his entry to the Milan court had been as an entertainer, storyteller and creator of theatre shows at the palace. The two men became lifelong friends and Leonardo would nourish himself on the older man's example. To get a court position he would have to take on any work he could get.

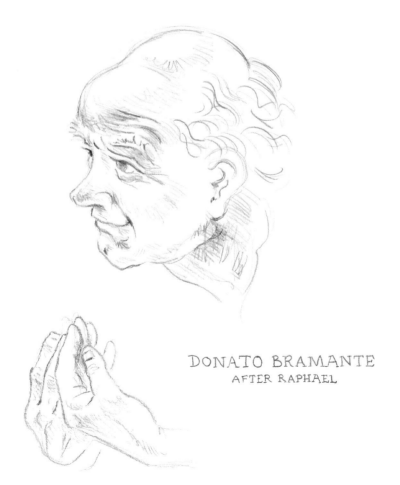

DONATO BRAMANTE
AFTER RAPHAEL

Whatever exists
in the universe the artist
has it first in his mind
and then in his hand.

LEONARDO

During the 1480s, Leonardo was still hoping for a permanent position at Milan's Sforza court, but his first official role was not as court engineer, exalted architect or even as a painter. Following in his friend Bramante's footsteps, Leonardo had gained a reputation as one of Italy's best raconteurs — an amazing feat in a nation where conversation is an Olympic-level sport! — and Leonardo's early years in Milan were predominantly employed as a court storyteller and entertainer. One of Leonardo's great jokes involves a painter of beautiful portraits whose own children are hideously ugly. The painter waves his hands plaintively, 'See, I make my paintings in the light and my children in the dark.'

Leonardo's frivolous role quickly morphed into official impresario for theatre shows and pageants. Ludovico Sforza spent a fortune on these extravagant entertainments for his courtiers, as well as public festivals.

This was the perfect role to showcase every facet of Leonardo's talent, and he thrived working across all the theatrical elements: designing fantastical costumes, writing scripts, choreographing action, arranging music, and using forced perspective techniques on the painted backdrops. He also engineered ingenious mechanics to fly actors above the audience or rotate the stage, just as you might see in a modern Broadway musical. Whatever Leonardo had in mind, he could create.

MILANO CANALS

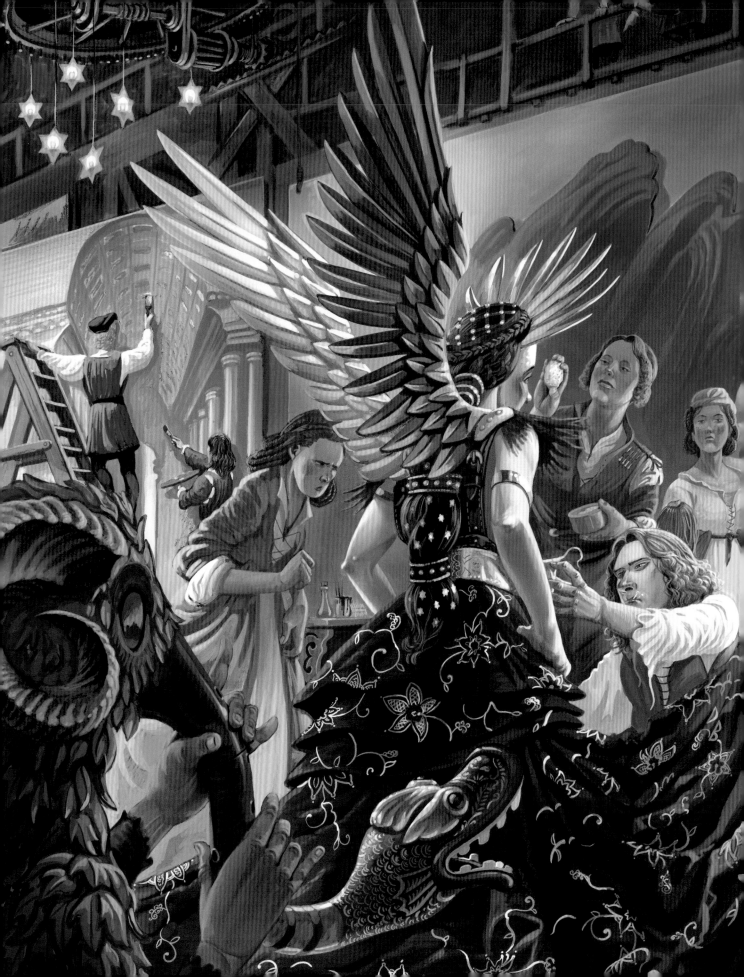

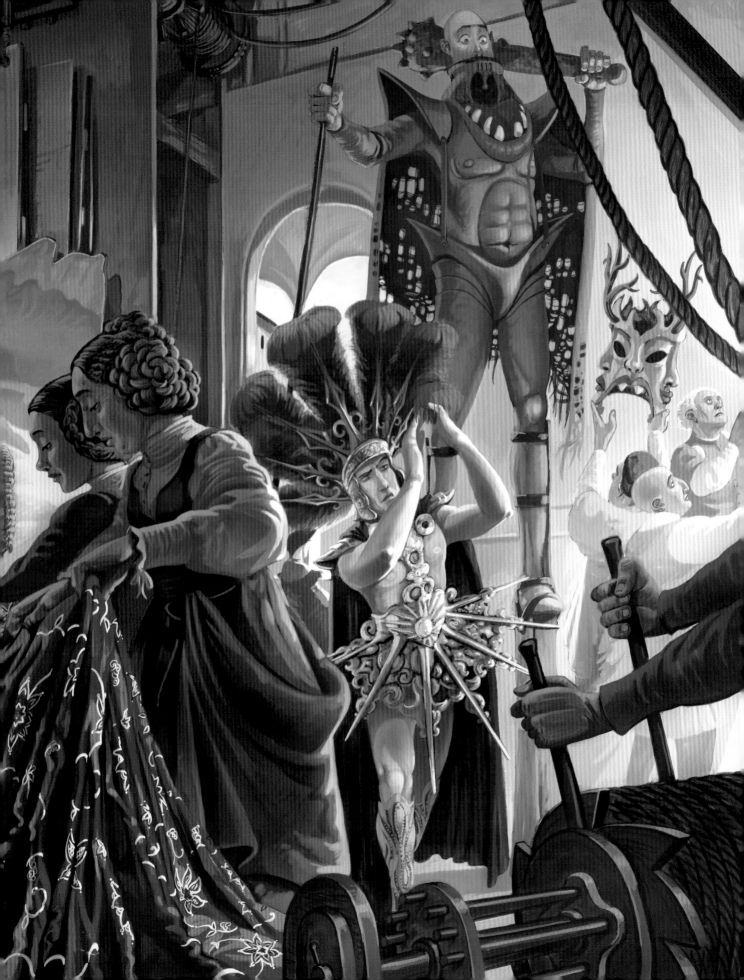

To devise is the work of the master, to execute is the act of the servant.

LEONARDO

ZOROASTRO

BOLTRAFFIO

GIULIO THE GERMAN

MARCO d' OGGIONO

NAPOLETANO

AMBROGIO de PREDIS

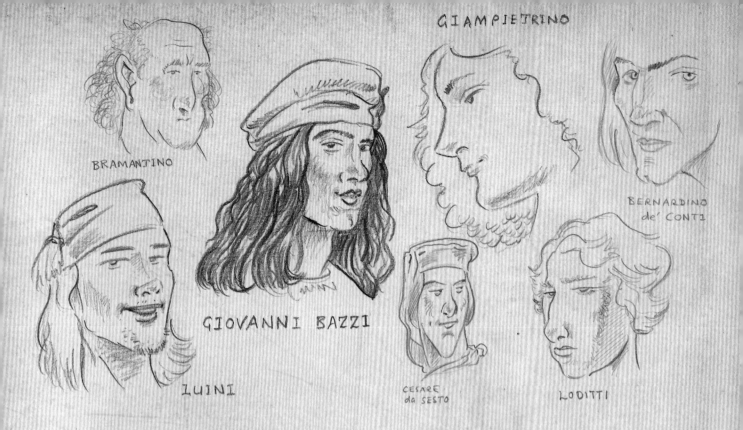

BRAMANTINO

GIAMPIETRINO

BERNARDINO de' CONTI

GIOVANNI BAZZI

LUINI

CESARE da SESTO

LODITTI

Leonardo soon set up his own workshop in Milan, following the form he knew from his old master's bottega in Florence. He was supervising artisans and subcontractors, metalworkers, glassblowers and makers of secret alloys, as well as dozens of students.

This group of followers helped popularise the 'Leonardo look' through their numerous copies and emulations of the master's paintings, with the maestro looking over their shoulders and adding a brush stroke here and there. At their best a few could match Leonardo in technical skill, although none were his equal in their own original artworks. Leonardo's notebooks show that he was responsible for quoting and budgeting major works, as well as handling the bureaucracy of wages, supplies and materials. The reality of the Renaissance artist is a far cry from the popular image — Leonardo was not a lone genius in his workshop, but the CEO and artistic director of a major creative studio.

RUSTICI

GIRARDO

SOLARIO

BENEDETTO

GALEAZZO

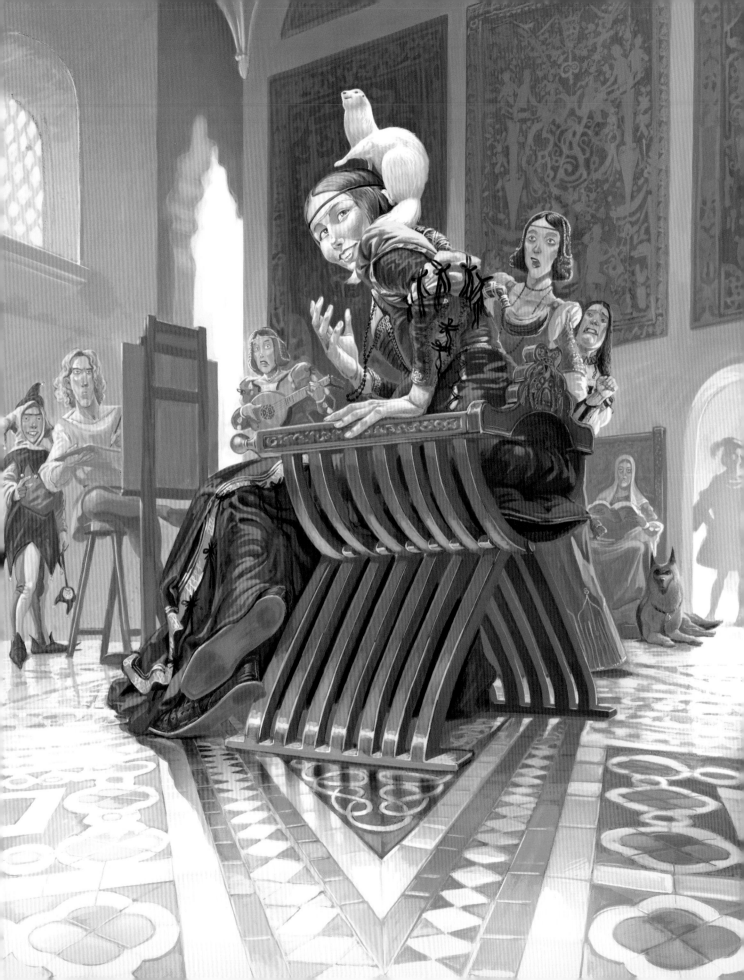

The eyes are the
window to the soul.

LEONARDO

Leonardo spent seven years in Milan before Ludovico Sforza finally gave him his first painting assignment at court — a portrait of Ludovico's gorgeous young mistress, Cecilia Gallerani. Leonardo always wanted to capture the soul of his subject and his photorealistic painting has since been described as the first modern portrait, with a dynamic energy that makes it seem like a snapshot compared to the standard portraits of the period.

Leo's love of ornate clothing is displayed in a series of court portraits done during these Milan years. In his writings on painting, Leonardo luxuriates in the comforts of the studio painter — dressed in fine clothes, perched in his soft chair, whilst poems and novels are read for him. In a fabulous tale, biographer Giorgio Vasari claims that Leonardo employed jugglers and minstrels to entertain his subjects. The innovative twisting portrait of Ludovico's mistress had the added challenge of managing a white ermine. So perhaps stoat-wranglers were among Leonardo's behind-the-scenes entourage for this painting?

Giacomo came to live with me … Thievish, lying, obstinate, greedy.

LEONARDO

GIAN GIACOMO CAPROTTI — SALAI

In July 1490 a ten-year-old boy came to live in Leonardo's household. It remains a mystery why the greatest artist of the age would take a farmer's son under his personal guardianship — Leonardo obviously saw something in the boy which resonated with him — yet there is no mystery as to what happened next …

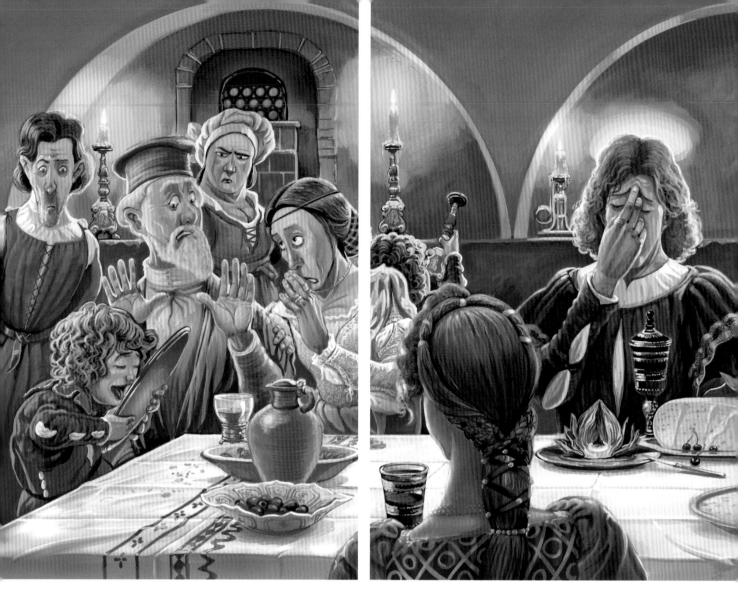

Within days of joining Leonardo's household, Giacomo was causing trouble, stealing money, and causing mischief at a dinner party. Not long after making this terrible impression at his first supper, Giacomo stole an expensive silver drawing stylus from one of Leonardo's visitors.

Giacomo pushed his guardian's forbearance to the limit, and over the following year Leonardo itemised an array of offences — multiple thefts committed and ill-gained goods pawned by the boy. Adding all the items to the costs for Giacomo's clothing for the year, Leonardo came up with a grand total of 32 lira (equivalent to the yearly wages

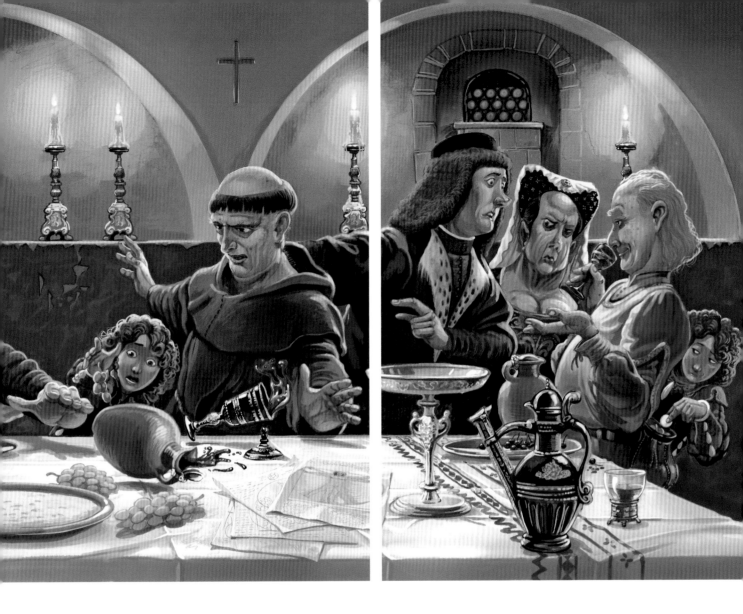

of one of his apprentice painters). In typical ten-year-old style, the boy had spent most of his ill-gotten gains on aniseed gobstoppers.

Over the next three decades the young man was to become a constant figure of exasperation as well as twinkling affection for Leonardo, appearing frequently in his notebooks among the drawings and designs as well as being the model for Leonardo's *Saint John the Baptist*. Through it all, Leonardo showed the patience of a saint, although he quickly gave his mischievous ward a new nickname, one that would stick for the rest of Giacomo's life and beyond for all posterity — Salai, the little devil.

If the artist wishes to depict creatures or devils in hell, with an abundance of invention he teems.

LEONARDO

Leonardo's workshop produced more than just paintings. Along with theatre productions, the workshop artisans were employed in creating armour and costumes for festivals and jousting tournaments. In 1491, Ludovico Sforza married Beatrice d'Este, and Leonardo's studio created a spectacle for the festival joust: a steed, covered with gold scales painted like peacock feathers, carrying an armoured rider who sported an incredible dragon helmet with a tail that ran down his back. Contrasting with this magnificent knight were a horde of unruly cavemen.

This side of Leonardo's creativity was far removed from the pious Madonnas his studio produced. It shows his undying love of fantasy creatures and was a real stimulation for Leonardo's other areas of interest. His festival creations would lead to designs for flying machines as well as innovations in painting techniques and experiments in perspective that he would soon employ on one of his greatest masterpieces, *The Last Supper*.

The definite deadlines for these grand festivals meant that, unlike so many of his paintings, these creations actually saw completion. Ironically, nothing is left of these extravaganzas except tantalising sketches and snippets from eyewitness accounts.

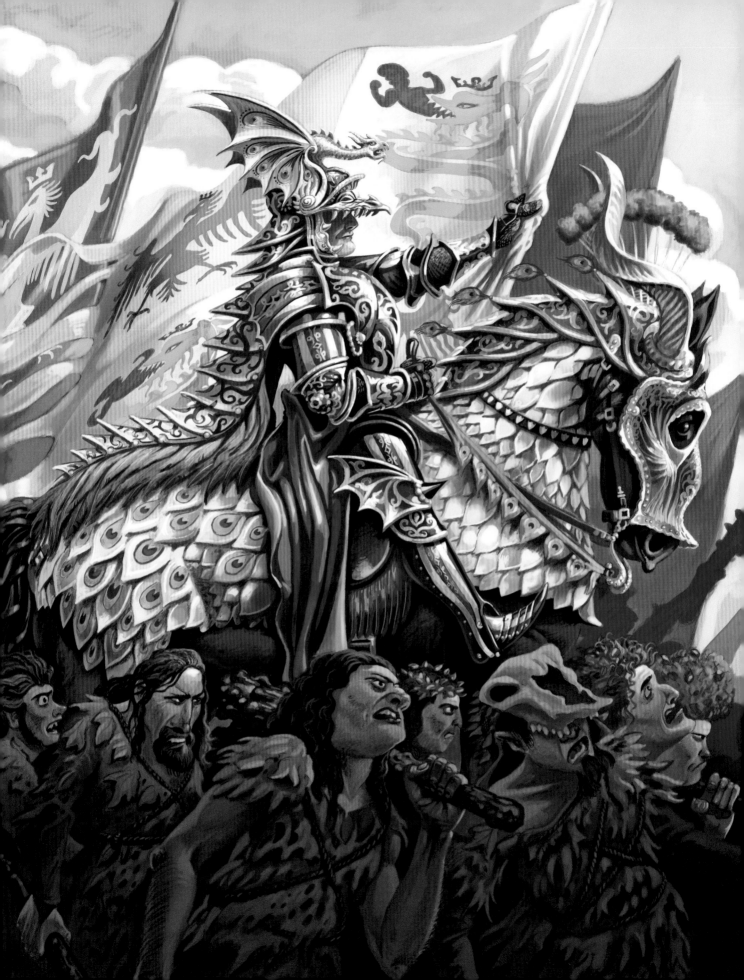

Feathers shall raise men even as they do birds, towards heaven.

LEONARDO

Throughout the centuries, people have been fascinated with Leonardo's flying machines. His designs revel in the fantastical side of his personality — the magical dreamer. The astounding feature of Leonardo's attempts to make manned flight is not whether he flew or failed, but rather the way he attacked these dreams with rigorous scientific and engineering problem solving.

Over two decades Leonardo explored all manner of flying contraptions, and his process led him to many of the designs we have today: the glider, the helicopter and the parachute. Even more remarkable is the inspiration he took from the wings of bats and birds. His fantabulous bat-wing design used a pine framework covered in fabric, similar to the techniques which would be used to make the first aircraft 400 years later.

Leonardo wrote copious amounts on flight and made models from paper. Through his tests he realised that the power and leverage needed to sustain a self-propelled flying machine were far too great. To complete the above quote: 'Feathers shall raise men … that is by letters written with their quills.'

In the end, Leonardo's most successful flying invention was the parachute. In 2008 his rudimentary design was put into action by a Swiss skydiver who, after leaping from two thousand feet, proclaimed it 'a perfect jump'.

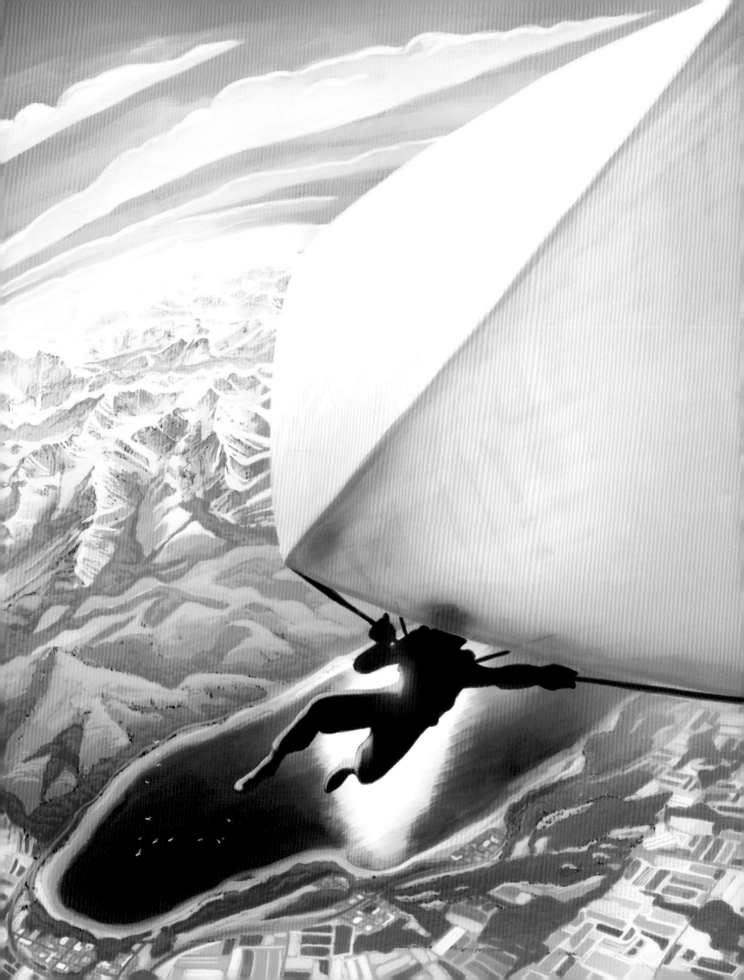

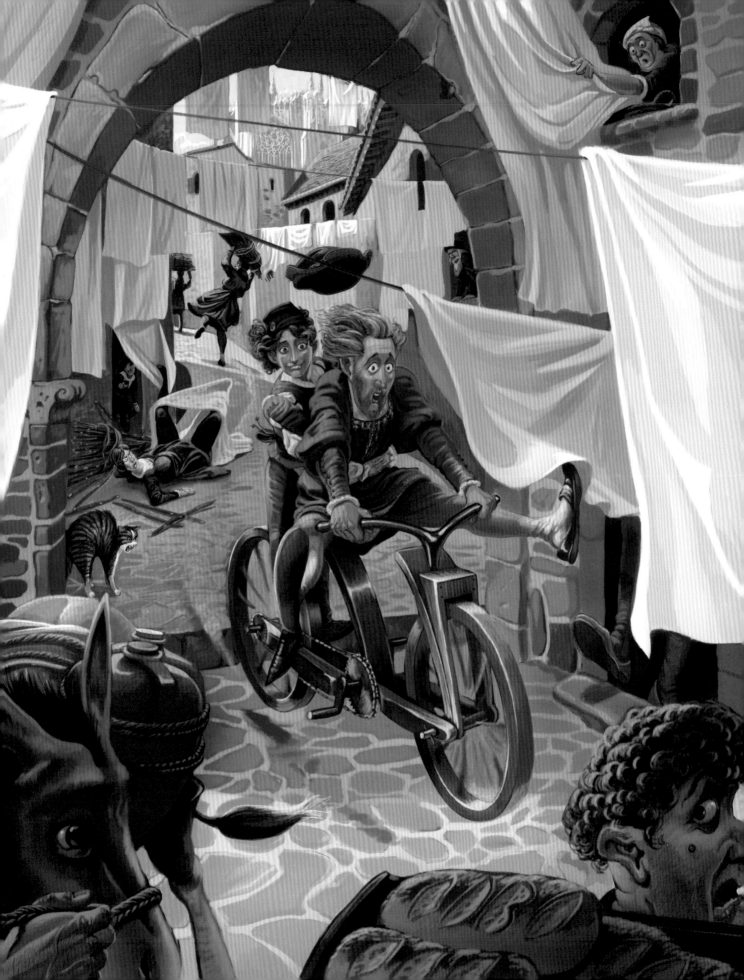

Human subtlety will never devise an invention more beautiful, more simple or more direct.

LEONARDO

One of Leonardo's most hotly disputed inventions was not discovered until the early 1970s. During the restoration of Leonardo's *Codex Atlanticus* sketchbook, pages were separated that had not been seen for 300 years. On the reverse of one of these pages was revealed a scribble clearly depicting a bicycle. The sketchbook's original collector had glued pages together which he deemed unimportant. According to the discoverers, this act preserved the authenticity of Leonardo's invention, while other scholars have claimed that the bicycle was forged during restoration.

Supporters of the find propose that the drawing itself is in the hand of Leonardo's twelve-year-old apprentice, Salai, who is obviously copying an invention he has seen in the master's workshop. Leonardo's authenticated sketchbooks from the period include drawings of an innovative chain-link to drive the wheels exactly like a modern bicycle. In many ways, the concept of a self-propelled two-wheel vehicle is far more original than Leonardo's dream of flying like Icarus. It also fits nicely alongside his machines intended to spare beasts of burden. Whether fake or fact, it's fun to imagine Leonardo testing his mechanical beast down Milan's cobbled lanes.

All hurts leave a pain in the memory except the greatest hurt of all, which is death, which kills the memory along with the life.

LEONARDO

Leonardo was forty-one when his mother came to live with his household in Milan. Her husband, Accattabriga, had passed away several years earlier, and her only other son had been killed by a catapult shot, fighting as a soldier in Pisa. Now in her late fifties, Caterina threw herself on the mercy of her eldest son, but a chance to build new memories in her last years was not to be. Malaria was rife in the city of canals and Caterina died of the disease within the year. Leonardo made sure his mother was given a respectful burial, but nonetheless, one suited to a weathered countrywoman. That old life was a whole world away from the one Leonardo now inhabited.

By this likeness the painter has injured nature.

ANONYMOUS*

As Leonardo's portraits became more realistic, they were celebrated for rivalling the real world. It's difficult to appreciate just how stunning his style must have seemed at the time. This photorealism was a pleasant by-product of Leonardo applying his scientific discoveries to art. However, through this process, his actual intention was to lift painting out of the lowly 'arts and crafts' guilds into the realm of the noble sciences.

During the fifteenth century there were many multidisciplinary creatives across Europe who were similarly interested in applying new discoveries in geometry, anatomy, physics, light, mechanics and perspective to the arts. As the century came into its last decade, it was Leonardo who was right at the bleeding edge of these developments. With his next big work he was about to take the science of painting into the 'High Renaissance'.

MILANO

* From a poem written at the time praising Leonardo's painting of Lucrezia Crivelli, another of Ludovico Sforza's mistresses. The painting is known as *La Belle Ferronnière*.

A good painter has two chief objects to paint, man and the intention of his soul; the former is easy, the latter is hard.

LEONARDO

A painting was never simply a painting for Leonardo. It was a chance to experiment with new materials and media. An opportunity to put into practice his scientific theories on light and natural phenomena, and to delve into the human psyche.

In 1495, Ludovico Sforza commissioned Leonardo to paint the back wall of the dining room in the chapel of Santa Maria delle Grazie, just a short stroll from Ludovico's moated castle. Leonardo chose to depict *The Last Supper* — and in ground-breaking style. He produced dozens of drawings of the Apostles, trying to portray each character as an individual and capture their inner emotions in the instant they are told that one of them will betray Christ.

Every morning and evening, Leonardo scoured Milan's shady Borghetto slums, searching for the perfect model to depict the treacherous soul of Judas. But after several years of working on the mural, the faces of Christ and Judas were still incomplete. The prior of the chapel complained to Ludovico Sforza, hoping to hurry Leonardo along. Instead, he got a sparkle of Leonardo's wicked wit. Leo cheekily shut down the protest by suggesting that he had finally found the evil face for Judas … in the priest!

Men of lofty genius sometimes
accomplish the most when they work least,
for their minds are occupied with their ideas
and the perfection of their conceptions,
to which they afterwards give form.

LEONARDO

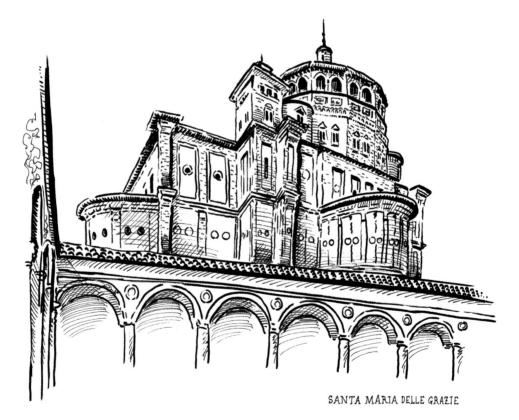

SANTA MARIA DELLE GRAZIE

When *The Last Supper* was completed in 1498 it was one of history's real 'wow' moments. The 7 x 8.8-metre mural had taken Leonardo and his team three years to complete. This was only possible because Leonardo was experimenting with a new technique that allowed him to paint slowly using a concoction of tempera and luscious oil colours*. Spectators crowded to see the maestro at work, although they often waited for hours as he stood before the mural contemplating his next brush stroke. At other times they saw him making an inspired dash to the chapel from his studio, oblivious to the scorching midday sun, just so he could add a single dab of paint.

Leonardo's masterpiece mimics the same lighting which shines through the chapel's left-hand window (which was installed at Leonardo's instruction), so that the figures appear bathed in natural light. Leonardo employed the skills he had learnt painting sets for court theatricals, and *The Last Supper* features complex tricks of perspective which a casual viewer would never notice. On top of all that is the psychological intensity Leonardo created in that exact moment he has chosen to freeze.

The result is breathtaking. If you stand at the far end of the dining room, twenty-five metres back from the gigantic image, it creates an uncanny effect, as if Jesus and the Apostles are floating just before you. In its original oil colours and photorealistic style, it must have seemed the equivalent of a modern viewer seeing a 3D movie for the first time.

The Last Supper was an instant sensation. It was Leonardo's most revered creation among his contemporaries, and cemented his brilliance far and wide. Ludovico Sforza was so thrilled that, on top of payment, he rewarded Leonardo with a vineyard opposite the chapel. And all of this from a genius for whom painting was just *one* of his interests!

* During this period murals were normally painted using the fresco technique. In this ancient method, used on paintings such as Michelangelo's Sistine ceiling, pigment was painted directly into wet plaster, and had to be completed quickly before the plaster dried.

What is fair
in men passes away,
but not so in art.

LEONARDO

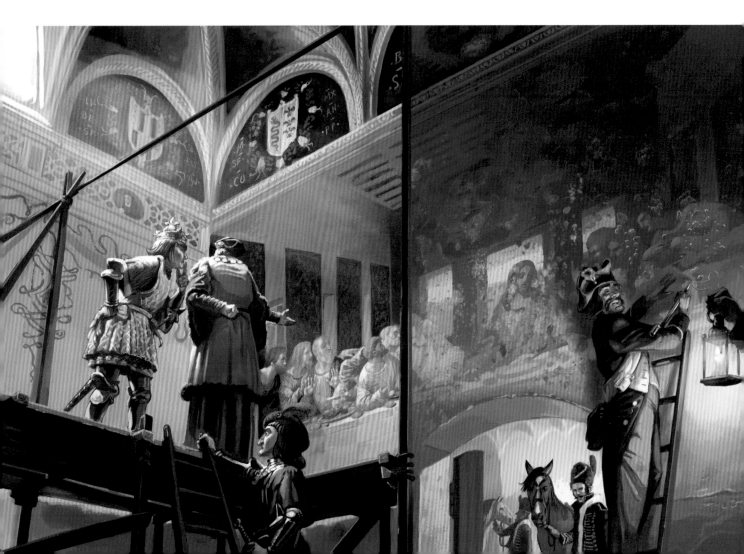

Unfortunately Leonardo's uncontrollable desire to experiment with painting techniques was not just ground-breaking — but simply breaking. Within a year, his magnificent *Last Supper* began to deteriorate, and that was not the famous painting's only problem. French King Louis XII contemplated the task of relocating the wall to France after conquering Milan in 1499. Three hundred years later, Napoleon's troops turned the refectory into a stables and vandalised the faded masterpiece. However, its closest call with annihilation came in the twentieth century.

During World War Two a bomb made a direct hit on the chapel, destroying almost everything except Leonardo's painting, which had been protected by sandbags. The massive mural has since undergone decades of loving restoration. Generations may have passed, but against all odds, Leonardo's *Last Supper* continues to survive.

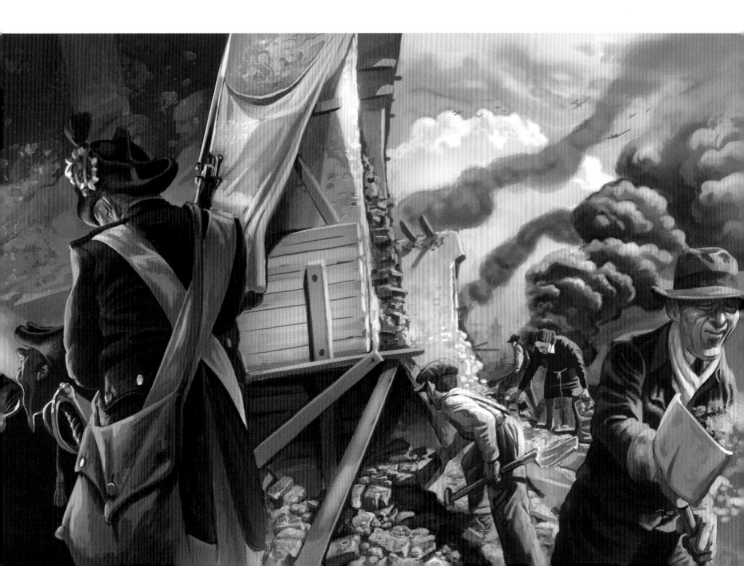

Leonardo the Florentine … has a work to do which will last him his whole life.

LEONARDO

Leonardo spent a good part of his seventeen years in Milan working on a great bronze horse. The sculpture was to commemorate Ludovico Sforza's father, the cavalry general who rose to become self-styled Duke of Milan. However, it's clear from Leonardo's drawings that his real interest was the horse, and not the rider.

The project consumed Leonardo, and his drive for perfection saw him distracted in the usual way, by a side project — a book on the anatomy of horses. Leonardo was a superb rider who adored horses, and that love is clearly evident in his sketches. No other artist of the era could match Leonardo's elegant and dynamic drawings of horses in motion. What remains today are only fragments of a vast work on the anatomy of horses that Leonardo was planning to publish.

In 1490, Leonardo finally knuckled down for three years of intense work on the bronze horse. He was always thinking big, and this time his ingenuity was pushed to the limit when the sculpture was increased in size to over seven metres tall. The finished piece was gigantic, dwarfing every other equestrian statue. When Leonardo unveiled his full-size test model, sculpted in clay, it caused a sensation with its flared nostrils and strutting realism, and it was frequently put on display to wow guests at the Sforza castle.

For centuries, all that was known of the bronze horse were tantalising snippets and rumours, until 1965, when Leonardo's notebooks on the project were rediscovered. They reveal his true inventiveness as a master sculptor and engineer. The project was four times larger than any other bronze sculpture, and Leonardo had to invent a new system to cast the mammoth artwork in one piece. He worked out every painstaking detail in a casting technique which would not be attempted again for another two hundred years. The moulds were made and Leonardo's customised furnaces were constructed, but his grand ambition was not to be.

You can imagine Leonardo's sheer frustration when the seventy-five tons of bronze set aside for the casting were requisitioned by the army to make cannons. Even more devastating, years later in 1499, as Leonardo fled Milan before the conquering army of French King Louis XII, his magnificent clay beast was reduced to rubble when the French archers used it for target practice.

Man, you have described yourself the king of the animals — it would be better for you to call yourself king of the beasts since you are greatest of them all!

LEONARDO

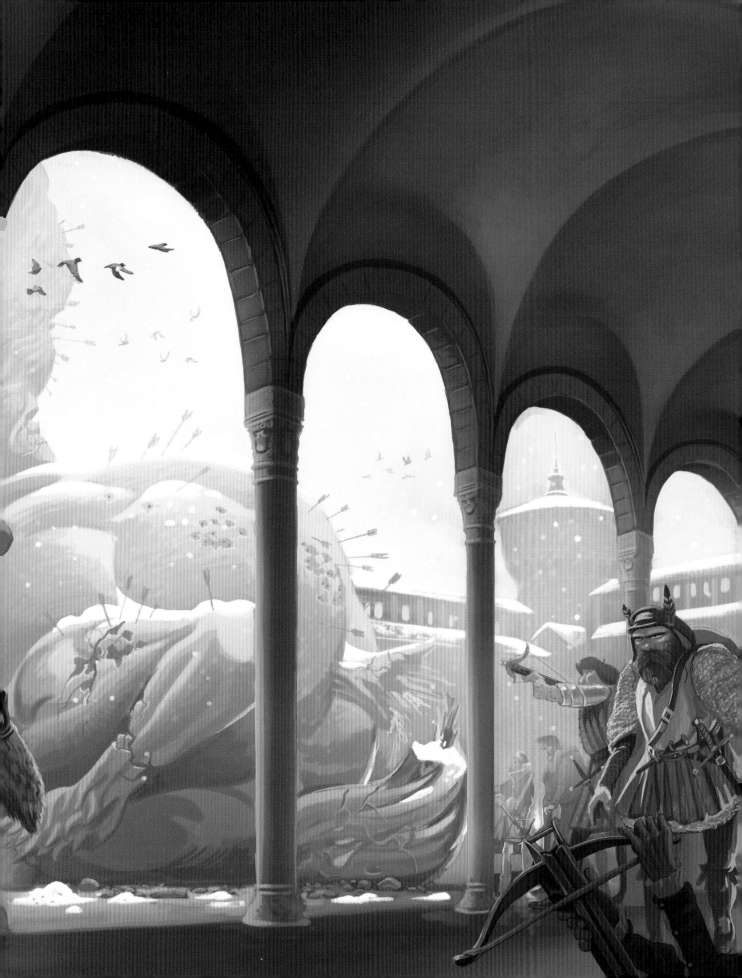

He who possesses most is most afraid to lose.

LEONARDO

Meanwhile, the city of Florence had been through some big changes during Leonardo's seventeen years away. The powerful Medici family had been frightened off as the French waged war on nearby Milan. Into this power vacuum swept a fundamentalist Dominican friar, Girolamo Savonarola — who had grown up not far from Leonardo's own birthplace. After decades of decadence, Savonarola whipped the Florentines into a frenzy of repentance, culminating in the famous bonfire of the vanities.

Into the blaze citizens threw their cosmetics, jewellery and fashionable clothes, along with books, artworks, instruments and furniture. Leonardo's old friend Botticelli became a follower of Savonarola, adding his own paintings to the fire, and some of Leonardo's early Florentine artworks went the same way. Thankfully, not all of Florence's artistic brilliance was lost, because city officials had sent many of their great artists (along with their work) out into the world, to spread the Renaissance to Rome, Milan and Venice.

Savonarola was eventually consumed by the fire too. The fickle Florentines turned on the friar, hanging and burning him in 1498. When Leonardo returned to Florence in 1500 the city had become dull and conservative. The loss of great artworks was one thing, but a greater loss was that the birthplace of the Renaissance would never regain its vibrant artistic freedom during Leonardo's lifetime.

I am no penny-painter.

LEONARDO

Leonardo carried an almost disrespectful attitude towards his most powerful patrons. On returning to Florence he found himself constantly harangued by one of the region's most wealthy women. Isabella d'Este wanted her portrait painted by Leonardo, and Isabella d'Este always got what she wanted. But Leonardo didn't like Isabella or her pestering lackeys. He begrudgingly whipped up a sketch of Isabella, devoid of his trademark twisting dynamism, but he couldn't muster the enthusiasm to turn it into a finished painting. His cheeky rascal of an apprentice, and young lover, Salai (now twenty), offered his own services, but Isabella wanted only the master himself. Leonardo's interests were remarkably unmotivated by money, and in sheer stubbornness he shrugged off Isabella's offer to pay 'any price'. He wasn't going to be bargained for like some market penny-painter.

Instead Leonardo began working on a portrait of someone else altogether, a painting for which he would never be paid — the *Mona Lisa*. Over the next nineteen years he endlessly finessed his most famous portrait, taking it with him every time he moved to a new city and working on it right up until his death.

Grotesque faces are kept in the mind without difficulty.

LEONARDO

Mona Lisa was the wife of a wealthy Florentine merchant, and while Leonardo clung to his original painting, the commission was probably delivered by one of the dozens of knock-offs made by his studio. Although Leonardo was quite happy rubbing shoulders with the lords and ladies of Florence, he could also mingle with the common folk and he would invite unusual-looking people off the streets into his household.

Here, he would feed his guests and entertain them with bawdy jokes and outrageous stories until they laughed uproariously. All the while, Leonardo was intently studying their expressions. Later he would turn these into over-the-top monstrous caricatures. These drawings are in stark contrast to Leonardo's refined *Mona Lisa* and the other glitzy courtesans he had painted back in Milan. His grotesque cartoons delight in a satirical roasting, and they clearly gave Leonardo great amusement.

One ought not to desire the impossible.

LEONARDO

For hundreds of years, the *Mona Lisa* was simply another painting in the French royal collection, seen only by aristocrats. During the French Revolution, in 1797, the painting was put on public display in the Louvre Museum in Paris, and although *Mona Lisa* was highly regarded by artists, it was not the universal icon it is today. All that changed in 1911, when *Mona Lisa* was stolen.

The theft coincided with the rise in photography and worldwide news distribution. Suddenly, all across the globe, people who had never even been inside a gallery were being shown a famous work of art on the front page of their daily papers. The media frenzy went on for years, spawning a multi-million-dollar industry in *Mona Lisa* merchandise, which stills exists today.

Ironically, the heist itself was not done for profit. The accused thief, Italian Vincenzo Peruggia (an employee at the Louvre), believed that *Mona Lisa* had been stolen by Napoleon. Peruggia claimed that his only desire was to return the painting to its true homeland. It was an impossible dream, because *Mona Lisa* had in fact been taken to France by Leonardo himself, and the painting had been in the lawful possession of the French royal family since Leonardo's death in France in 1519.

On his misguided quest, Peruggia kept the painting hidden in a trunk in his apartment and after two years he was eventually arrested in Florence. The *Mona Lisa* was returned to the Louvre in 1913, but not before making a spectacular tour through Italy and being splashed across the news of the world again, cementing its place as history's most famous painting.

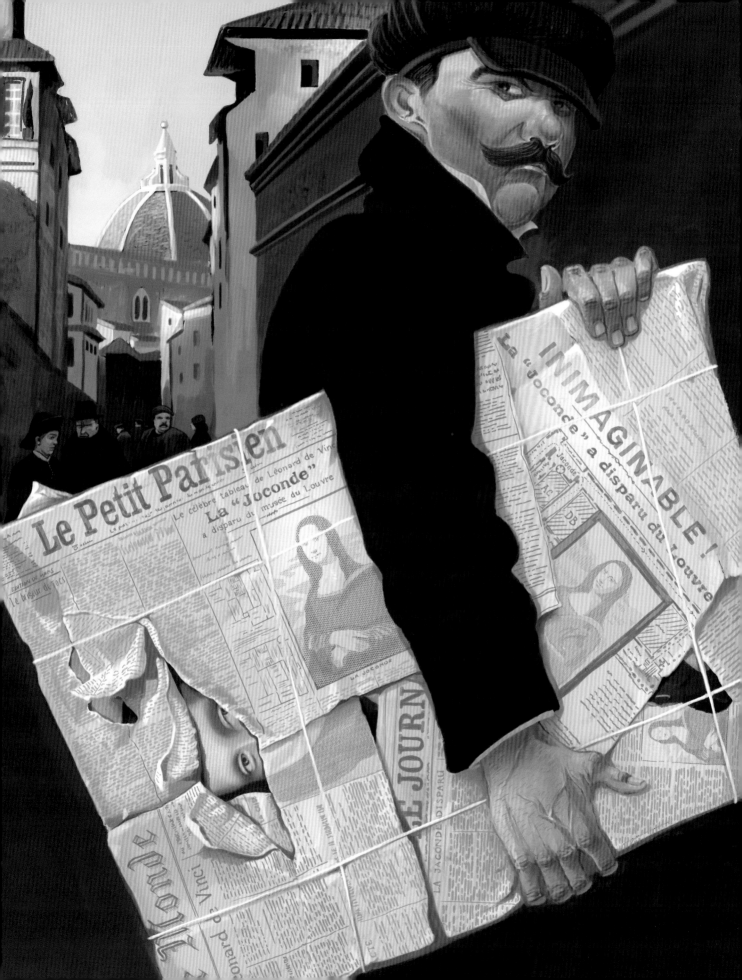

Painting has no need for interpreters.

LEONARDO

With his return to Florence, Leonardo had become wildly famous. He was leading the way into a new era, where artists had become superstars. In 1501 he put on display a large preparatory drawing for a painting of the *Virgin and Child with St Anne*. For two days people from all walks of life flocked to see the sketch, as if attending a grand festival.

Leonardo felt that a painting should speak for itself, and he often put his work in progress on display to observe the public's reactions. He recognised that even the most common peasant could tell if a human form was natural or not — and Leo was all about naturalness and fluidity of movement and emotion. 'While a man is painting', Leonardo wrote, 'he ought not to shrink from hearing every opinion.' One of Leonardo's surviving cartoons* for the *Virgin and Child with St Anne* is now in London's National Gallery where the public continue to be awed by his supreme draughtsmanship.

* The word cartoon comes from the Italian cartone, meaning a large sheet of paper, and in a historical context, cartoon refers to a full-scale preparatory drawing for a finished painting.

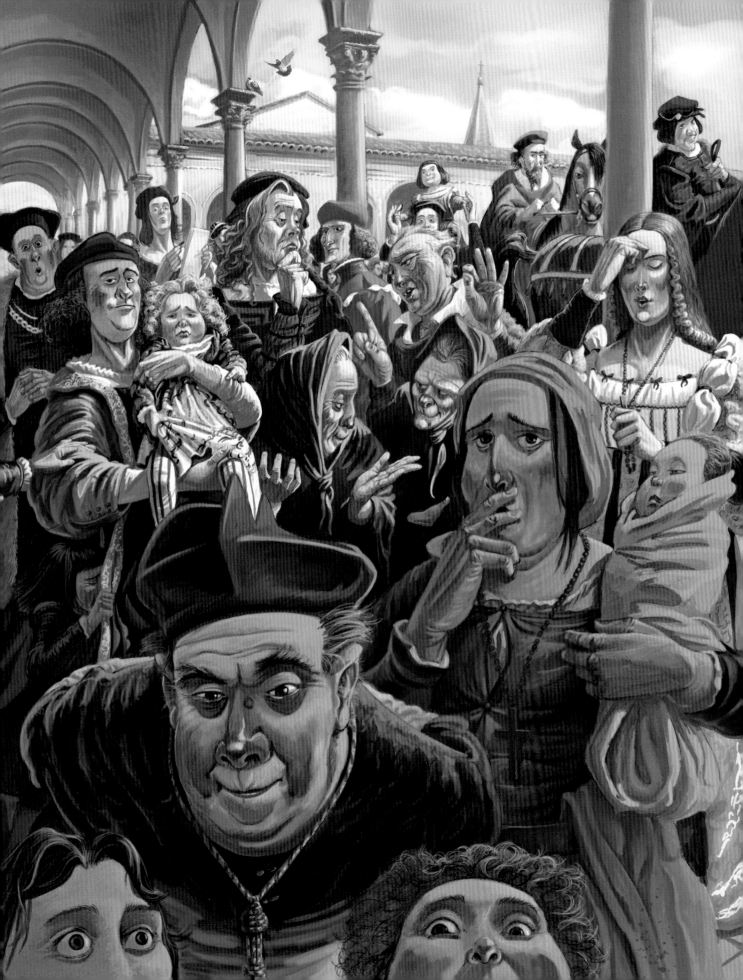

Save me from strife and battle …
a most beastly madness.

LEONARDO

Leonardo had barely settled back in Florence when he was once again used as a diplomatic pawn. The warlord Cesare Borgia was carving out a state for himself through central Italy, conquering all in the name of his father, the Pope. In 1502, Borgia flexed his muscle towards Florence and the city fathers surrendered without a fight. They paid Borgia a massive amount to play nice, and to sweeten the deal offered up Leonardo and the diplomat Niccolò Machiavelli. Leonardo eagerly packed his sword and notebooks and trotted off to join Borgia's army. Finally, here was his dream job to be an official military engineer, twenty years after that ambitious job application to Ludovico Sforza.

Leonardo was made a General and given a passport which commanded all to give him any assistance he needed — and his work was essential, including engineering fortifications and map-making. In one instance, Leonardo helped Cesare's army to cross a river by constructing a self-supporting bridge solely from notched logs without nails or rope.

Leonardo witnessed sieges and battles and gruesome atrocities, writing, 'it is an infinitely atrocious act to take away the life of a man'. So how did Leonardo reconcile his peace-loving humanism with the brutalities of war? For a start, he kept any personal opinions on Cesare's methods secret — a wise move when spies are reading your every message, and paranoia, murder and betrayal are in the air. Machiavelli would go on to use Cesare Borgia as a model of cunning ruthless leadership in his famous book *The Prince*, from which we get the term 'Machiavellian'.

As Leonardo followed in the dust and destruction of Cesare's army, he distracted himself from all the madness by doing what he did best … he pulled his notebook from his belt and looked the other way: sketching an unusual window frame during the sack of Cesena, the palace steps in Urbino, and the mechanism for a church bell during the conquest of Siena.

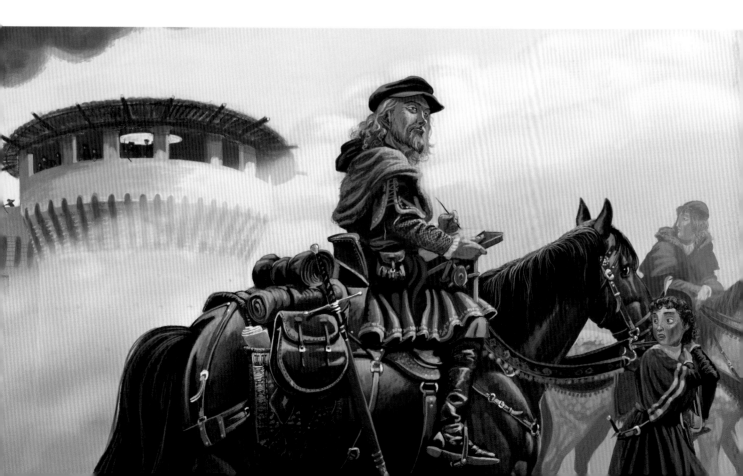

Why does the eye see things more clearly in dreams than the imagination when awake?

LEONARDO

As Cesare Borgia's chief military engineer, Leonardo was tasked with creating maps, depicting valleys, hills, marshlands and fortifications — essential information for a conquering army. Leonardo had already invented an odometer, which measured distance by counting turns of a wheel, just like in a modern vehicle. With this invention he was able to make a remarkably accurate map of Borgia's base in the town of Imola. The resulting drawing looks as if it has been taken straight from a satellite image.

Leonardo's most striking maps are a combination of topographical data and his own imagination. He flies there in his mind and shows us a 3D bird's-eye view, soaring high over the landscape*. The innovation and usefulness of these maps would have been like providing Borgia with a drone camera.

Eventually Borgia's rampage through central Italy settled down. After eight months in the saddle Leonardo had had enough of the army and he headed back to his life in Florence.

* The landscape in the painting to the right is taken from one of Leonardo's 'bird's-eye' maps.

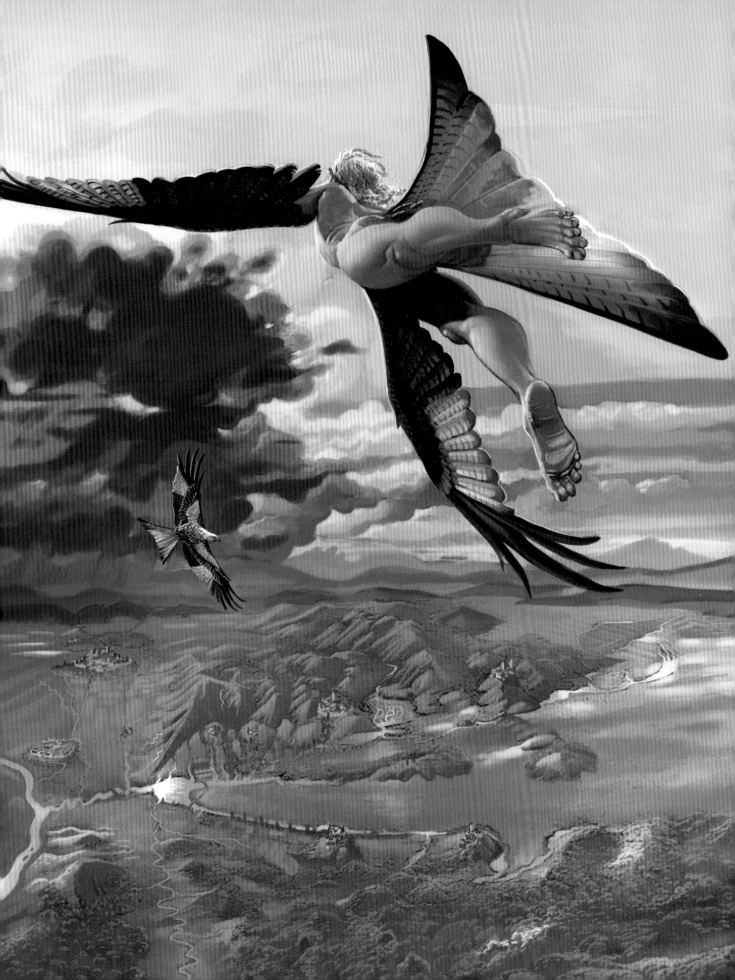

Sculpture is less intellectual than painting.

LEONARDO

During Leonardo's years in Milan, a rising star had taken his place as the greatest artist in Florence. Leonardo had not long returned from serving in Borgia's army when he was caught up in a war of words with this prickly upstart — Michelangelo Buonarroti.

Leonardo scorned the young sculptor as a company man and sell-out, while Michelangelo accused the older artist of never finishing anything, making fun of Leo's great horse in Milan. That colossal sculpture had been destroyed, while Michelangelo had completed what he thought to be the greatest sculpture of all time — his magnificent *David*.

Public arguments raged over where to place Michelangelo's masterpiece, and in 1503 Leonardo was part of a committee tasked with making the final decision. The imposing sculpture was eventually positioned outside the city council buildings (today the Palazzo Vecchio). However, at Leonardo's insistence, *David* was originally compelled to don a gilded leaf to modestly cover his nakedness. It's impossible to know whether this was prudishness on Leonardo's part or a genuine artistic difference. Michelangelo loved the male nude and Leonardo loved ornate decoration. On the other hand, Leonardo had taken some cheap shots at grime-covered sculptors and their lesser art. Perhaps this was just a chance for Leo to cause mischief and score a petty point against his young rival.

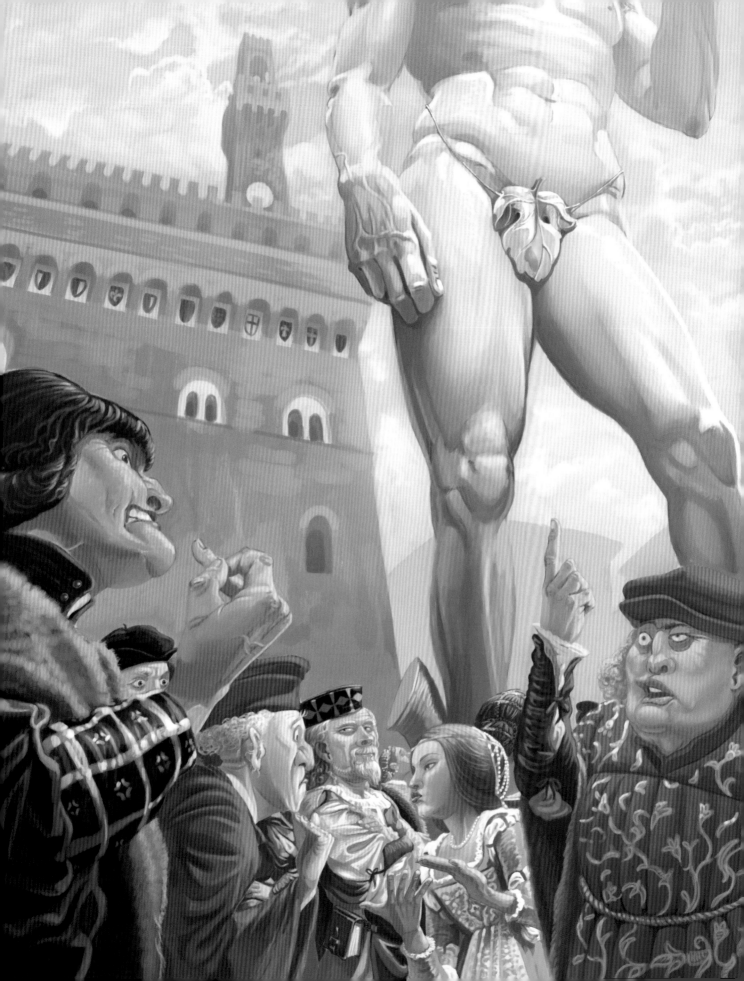

Perhaps you are lacking in patience, so that you will not be diligent. Whether or not I possess all these qualities will be attested.

LEONARDO

In 1504 the Florence city fathers decided to stage a great public battle — not between warriors, but an intellectual and artistic paint-off between their two most famous sons ... Leonardo da Vinci and Michelangelo Buonarroti. Each artist was given a wall to paint in the city offices: two absolutely gigantic murals facing each other.

The battle was multilayered. Here were two of the greatest artists in history, both gay — one devoutly religious and repressed, the other borderline heretical and flamboyant. Even their chosen scenes were contrasting. Michelangelo opted for a moment of broken calm just before the *Battle of Cascina*, while Leonardo chose the furious tumult of fighting around the flag bearer in his *Battle of Anghiari*. Leonardo had witnessed war first-hand on his campaigns with Cesare Borgia, noting the variations of light amongst the smoke and dust while bloody bodies are dragged in the mud behind their horses.

As usual, Leonardo was soon distracted from the actual painting. Instead he spent time inventing a scaffold which could move up and down like a modern scissoring platform. He was also continuing his experiments with painting materials. Once again these methods proved hopeless and Leonardo was forced to light fires to dry his dripping image. It was a disaster. Both artists lost patience and abandoned the project, but tantalising remnants were left for decades and copied by other great masters*.

* The walls were eventually painted over by Giorgio Vasari fifty years later.
 Vasari was a devoted fan of both Michelangelo and Leonardo and it is
 proposed by some experts that he built a false wall over the old paintings.
 Perhaps the originals may still be underneath in Florence's Palazzo Vecchio today?

Obstacles cannot bend me.
Every obstacle yields to effort.

LEONARDO

Leonardo never separated art from science, and because of that he was able to combine his studies in interesting new discoveries. He designed endless devices to overcome his obstacles; from flotation skis for walking on the river, to glass tanks where he could study coloured dyes flowing through water in a controlled environment. He wasn't sending others to do his dirty work either — he was right there doing it himself.

Science was a hands-on pursuit for Leonardo. He hoped that by diving into Florence's Arno River, armed with his underwater breathing mask, goggles and flippers, he could observe fish moving through the currents. This in turn would help him understand the invisible currents of air in his quest to understand flight.

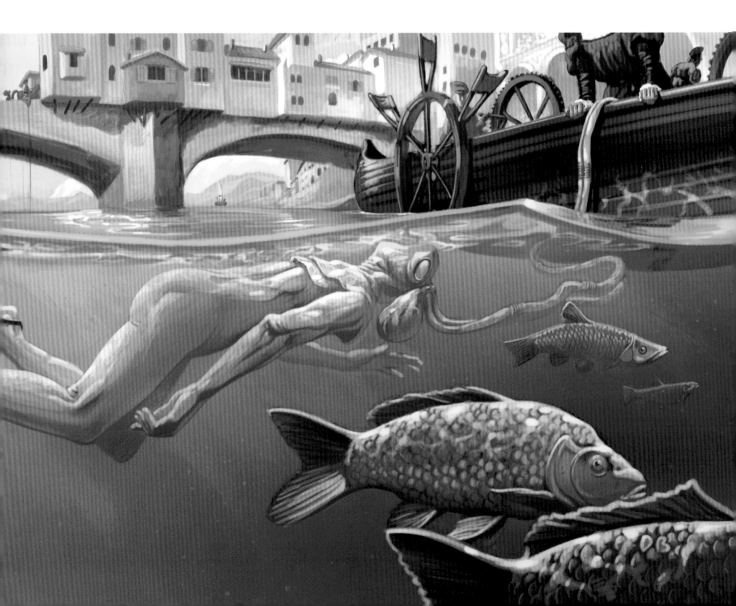

Avoid the teachings of speculators whose judgements are not confirmed by experience.

LEONARDO

Leonardo preferred the glamorous French royalty in Milan to the dreary city councils in Florence, and in 1506 he was drawn back to Milan and all its royal trappings. But this time he returned as 'official painter and engineer' to French King Louis XII. Leonardo had been back a year when a new pupil joined his studio. Francesco Melzi was a beautiful teenager, and his arrival must have thrown Leonardo's favourite, the rascally common-born Salai, because Melzi was not only handsome, but an educated nobleman.

At this time, Leonardo's mother and father had both passed away, along with his beloved Uncle Francesco. Leonardo was estranged from his half-brothers, who were fighting for Uncle Francesco's inheritance (which had all gone to Leonardo). It seems no coincidence that another Francesco should take such an important role in Leonardo's world. Leonardo must have been thinking on mortality and the importance of family, and in a very short space of time he adopted Francesco Melzi as his son and heir.

Melzi had the most experienced teacher one could hope for, and although none of Leonardo's pupils could ever outshine their master, Melzi would become a fine painter. It is around these years that Melzi drew a beautiful portrait of his adopted father. The drawing shows an ageing Leonardo, still handsome and fine-featured, with long flowing locks, a refined beard and elegantly groomed moustache. To the end of Leonardo's days, Melzi was constantly at his side as a son, secretary, collector, assistant, and a talented artist — a worthy inheritor and executor of Leonardo's legacy.

The ancient bottoms of the sea have become mountain ridges.

LEONARDO

Wherever Leonardo went he saw incredible wonders in the everyday world. Climbing in the Italian Alps north of Milan, he described a gigantic cloud like a flaming explosion. His magpie mind flitted between alpine flowers and ancient fossils embedded in layers of rock.

He understood that every action had an equal and opposite reaction no matter how small, stating that 'the earth is moved from its position by the weight of a tiny bird resting upon it'. He knew that the moon was a planet and he concluded that the shells and fossils of fish he had seen throughout his life had been set into the rock in such a way that the ancient seabed must have risen up over aeons — a remarkably accurate observation pre-dating plate tectonics.

Nothing was too great to contemplate. Yet, no question was too insignificant to warrant his interest either. From his intense studies of light, he correctly deduced why the sky is blue and he knew that different light waves bounced off particles in the air, making the sky red, like that fiery cloud towering over the Alps. These tiny questions fascinated him — such as the physics of how you can slide on ice without toppling over.

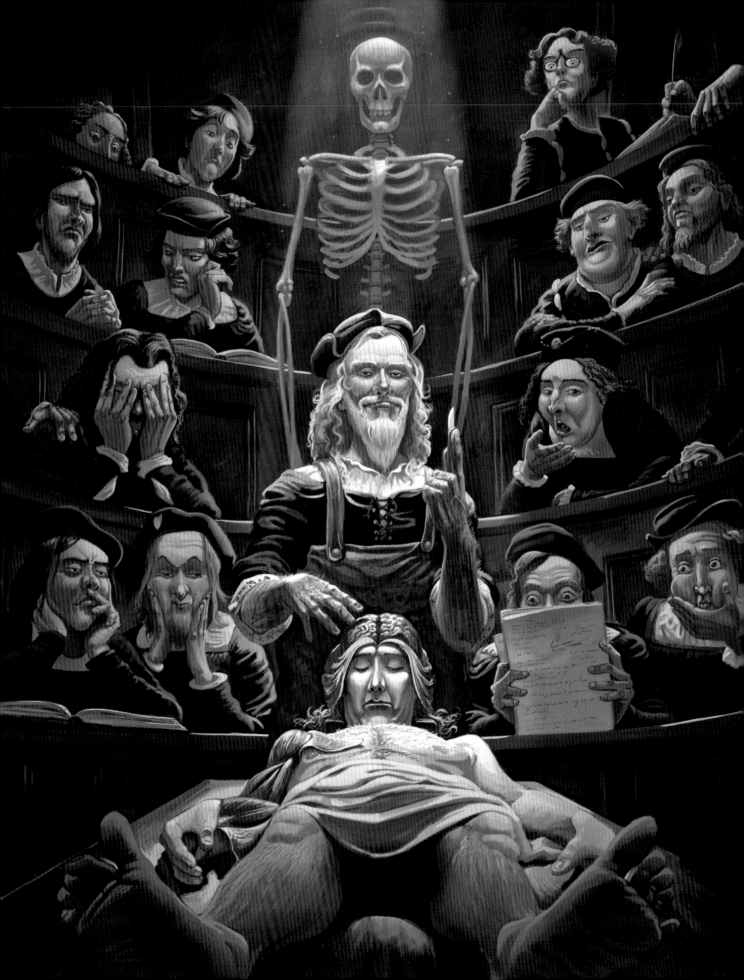

You will perhaps be deterred by your stomach; and if this does not deter you, you may be deterred by the fear of living through the night hours in the company of quartered and flayed corpses.

LEONARDO

One of Leonardo's most intense interests was his anatomical studies. Beginning in 1489 and spanning twenty-five years across various cities, he dissected and made the most incredibly detailed drawings of more than thirty bodies. This was only possible because of the period in history he occupied. A century earlier, Europe had been in the Dark Ages, while in coming decades dissections would be outlawed during the puritanical fervour of religious inquisitions.

The task Leonardo set himself was ridiculously ambitious — simply to describe life and how the body works! But he kept delving deeper and deeper. His discoveries on the inner working of muscles and tendons informed his other projects, from musical instruments to refining *Mona Lisa*'s smile. His exquisite drawings explaining how the valves of the heart operate were hundreds of years ahead of other scientists.

We glimpse a unique side of Leonardo — dissecting bodies as part of group studies at the University of Pavia, then at other times alone in the cold of night in hospital basements. His un-squeamishness and empirical non-superstitious character is almost gleefully boastful of how many nights he can withstand before the putrefying corpses are too horrific, even for him.

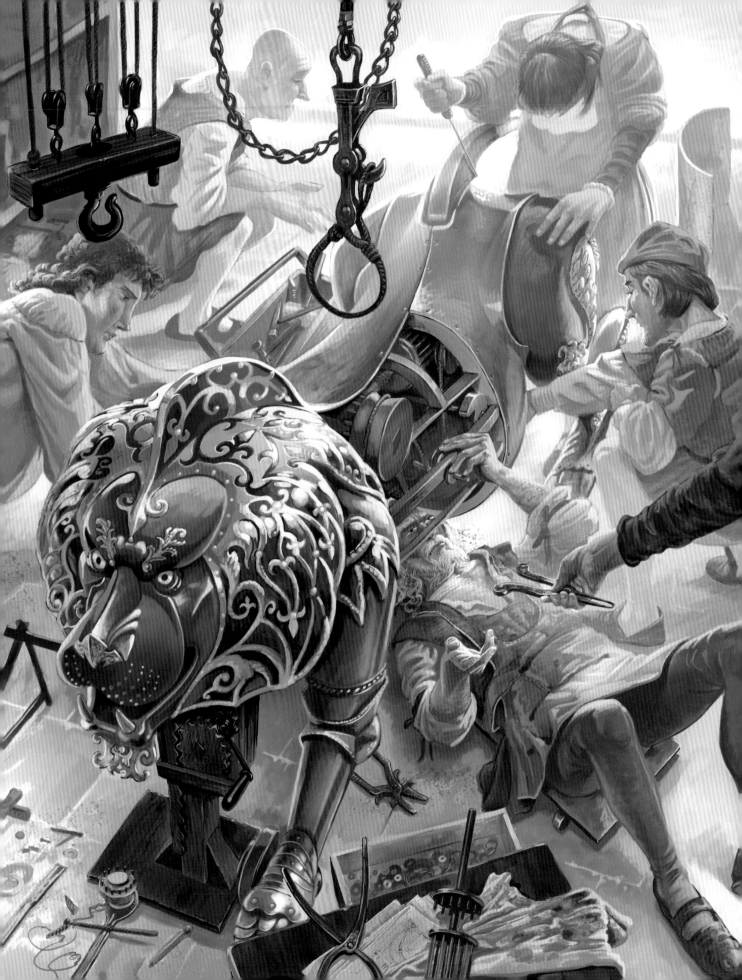

Marvellous instrument, invented by the supreme master.

LEONARDO

Leonardo was brilliant at combining his studies in mechanics and automation with his love of theatrical showmanship. He created a variety of robots, including a knight and a wheeled vehicle, which are regarded as the first programmable analogue computers. Leonardo's most famous robot was a great lion, that rose to its feet and opened its breast to reveal a bunch of fleurs-de-lys. The lion was created for celebrations welcoming France's King Louis XII into Milan and it was yet another Leonardo sensation to be brought out for various festivities in subsequent years.

Leonardo's very name and his family coat of arms associate him with the lion, but his mechanical lion also serves as a symbol of why he moved from Florence back to Milan. Milan had kings and pageants and excitement, away from the nagging committees and family dramas with his siblings back in austere Florence.

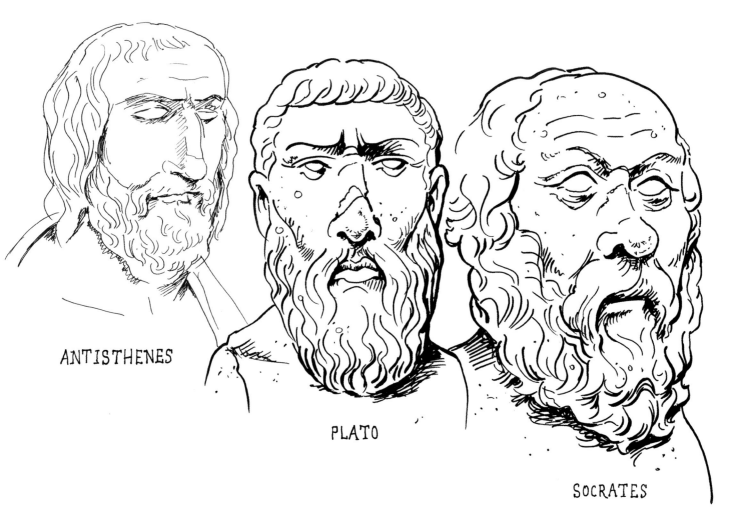

ANTISTHENES

PLATO

SOCRATES

Characteristics of the face reveal the character of men.

LEONARDO

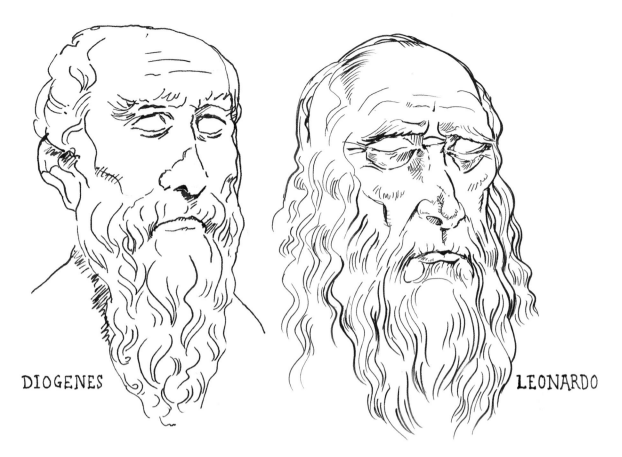

DIOGENES

LEONARDO

At the end of 1513, Leonardo relocated to Rome with his large entourage of students, assistants and household staff. The move to Rome coincided with the ascension of Pope Leo X — the first Florentine Pope, and the son of Leonardo's first patron, Lorenzo de' Medici. The Pope's younger brother, Giuliano de' Medici, gave Leonardo a comfortable salary and spacious apartments in the Vatican's Villa Belvedere.

Next door, Leo's best friend Bramante was leading a massive team of builders and architects on the construction site of Saint Peter's Basilica. Earthworks around Rome had uncovered amazing sculptures from ancient times. Leonardo helped to restore and curate some of these, which were put on display in the very apartments where he was living, and are still viewable there today.

In the ancient busts of Socrates and Plato, Leonardo found a new ideal — a chance to reinvent himself again. In his most iconic self-portrait, Leonardo ditches his well-preserved looks and creates a vision of himself sporting a stern countenance, with blank eyes under bushy brows and a ragged beard. He had often written that appearance revealed the inner man, and now he began moulding himself as a great philosopher in both mind and image.

Through the interposition of spectacles the object is clearly discerned.

LEONARDO

In Rome, Leonardo became obsessed with lenses and optics, as well as continuing his anatomical dissections. Combining the two sciences, he made some breakthrough discoveries.

Leonardo's dissections of human eyeballs had revealed distortions in the cornea as people aged, and Leonardo could see a solution to the problem. He devised an experiment that corrected the distortion by creating an artificial lens using water, which worked in the same way that contact lenses work today.

Now sixty-one, Leonardo's own sight was fading. He already had a pair of blue glasses that he had bought in Florence, and now, using his customised grinders and polishers, he fashioned himself a pair of spectacles to discern his world more clearly.

He formed in his mind a doctrine so heretical that he depended no more on any religion, perhaps placing scientific knowledge higher than Christian faith.

GIORGIO VASARI ON LEONARDO

Things started off well in Rome. The city was in the throes of a full artistic rejuvenation and Leonardo's old Florentine friends and rivals were all busily creating masterpieces. Botticelli and Ghirlandaio had painted the walls of the Sistine Chapel, and Michelangelo had just completed the chapel's magnificent ceiling. Meanwhile, young Raphael was painting his great rooms for the Pope — yet Leonardo was not invited to contribute to any of this grand undertaking.

Instead, Leonardo was experimenting with mirrors and lenses. He conceived gigantic discs which could focus beams of sunlight to burn enemy ships, as Archimedes had legendarily done in ancient Greece. The whole idea seems like an utterly boyish fantasy, although the military angle was perhaps a way to keep his patrons invested while Leonardo worked on his own scientific experiments.

Whether or not patrons had lost faith in Leonardo the artist, Leonardo had certainly lost interest in art. A contemporary at the Vatican wrote that Leonardo now despised the brush in favour of philosophy and science. But, where art was heaping fame and fortune on his faith-based contemporaries, science would bring enormous trouble to Leonardo.

What think you man! Are you as wise as you set yourself up to be?

LEONARDO

Despite his wisdom, Leonardo did not have a divine pipeline to the workings of the cosmos. He was a man of his times trying to make sense of the world through experiment. 'Test, test, test' is dotted like a mantra throughout his notebooks over his whole lifetime. Even so, Leonardo had some wacky ideas that were stuck in the mind-set of the ancient Greek philosophers — theorising that muscles were inflated by air and that bone marrow was the source of sexual reproduction. On the other hand, many of his experiments presage the work of scientists such as Galileo and Newton, in gravity, optics, anatomy, astronomy and futuristic inventions.

In Rome, he developed a paranoia that others were out to steal his inventions. Even worse, some of these rivals publicly condemned him as a heretic for his ideas. It's no wonder that Leonardo was afraid to share his discoveries, and in turn, share in the feedback of other scientists and engineers working on the same problems. So, despite shedding light on some of the great scientific mysteries, he was also responsible for keeping these discoveries in the dark. This is one of the reasons why so much of his life's work was lost and had to be rediscovered centuries after his death.

If the artist wishes to create monstrosities that are frightful and buffoonish … he is lord to do so.

LEONARDO

As the years in Rome continued, Leonardo became even more secretive about his science projects, complaining incoherently about colleagues stealing and hindering his work. Among this strife he was denounced before the Pope as a heretic for his continued anatomical studies, in particular one dissection involving a female cadaver with an unborn child. Trouble arose when Leonardo questioned whether the child possessed a soul. During this time Leonardo's writings become disjointed and ranting. His tone takes on a teenage surliness, questioning exactly what he's doing in Rome.

It says something of Leonardo's fickle status at the Vatican that he was the first person whom the gardener approached after discovering a large unusual lizard in the Vatican's rambling gardens. Leonardo found a hilarious outlet for his frustrations by fixing wings, scales, horns and a beard to the creature — taking petulant delight in terrifying the Vatican staff with his pet dragon!

Alas, this man will never get anything done, for he is thinking about the end before he begins.

POPE LEO X ON LEONARDO

BASILICA DI SAN PIETRO

Pope Leo X never granted Leonardo any grand commissions in his Vatican palace. However, this allowed Leonardo to explore other interests. With a guaranteed income, and free from tiresome painting commissions, Leonardo indulged his love of childlike delights.

For the Vatican staff Leonardo devised frivolous entertainments, such as inflating the intestines of a steer to fill an entire room, or constructing fantastical wax creatures which could be filled with air and released to fly about the papal apartments. A favourite of Pope Leo X was an indoor firework effect that Leonardo created by mixing powdered varnish with evaporated brandy. When thrown into the air and ignited, the powder would make the room sparkle and fizz — do not try this at home!

But things weren't all fun and games. When his patron, the Pope's brother Giuliano de' Medici, died in 1515, Leonardo wrote: 'The Medici created and destroyed me.' Combined with those heretical claims from jealous rivals, it was time for Leonardo to move on again.

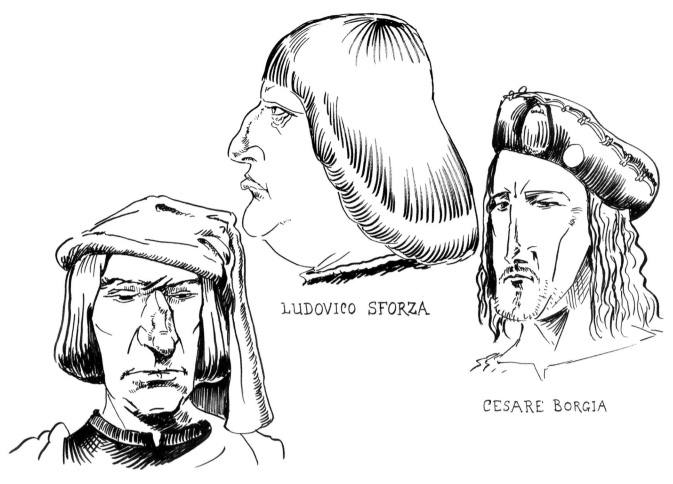

LUDOVICO SFORZA

CESARE BORGIA

LORENZO de' MEDICI

The greatest deception men suffer is from their own opinions.

LEONARDO

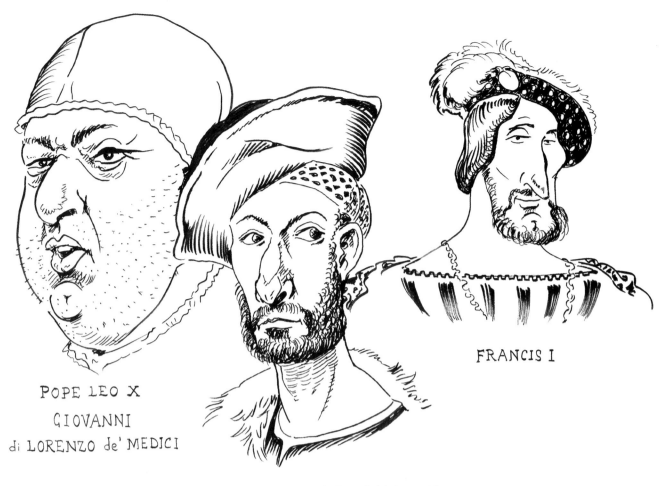

POPE LEO X
GIOVANNI
di LORENZO de' MEDICI

FRANCIS I

GIULIANO di LORENZO de' MEDICI

Throughout his life, Leonardo was attracted to strong male leaders, and much has been written seeking an explanation in his upbringing as an illegitimate child, or in some aspect of his sexuality. In truth, Leonardo was rather ruthless himself. He cultivated a detachment from his patrons so that he was never their slave. He had no compunction about using the era's most powerful rulers as stepping stones to his own interests and he was remarkably strong-willed and stubborn — painfully procrastinating on official projects while using their money and facilities to continue with his own side projects.

In the end, the immensely wealthy bankers, the dukes and vicious warlords, even kings and popes were all deceived by their own importance. When each in turn lost their estates, Leonardo simply upped sticks and moved on to the next powerful lord.

As a well-spent day brings happy sleep, so a well-employed life brings a happy death.

LEONARDO

Leonardo had spent his life flitting from one powerful patron to the next — but none had really given him satisfaction. Now, aged sixty-four, he found his perfect match in the new French King, Francis I. In 1516, Leonardo, his adopted heir Melzi, and the household staff, set out from Rome on the sixty-day journey to the French court at Amboise in the Loire Valley.

There were cartloads of journals, sketchbooks, trunks of clothing and household items as well as the three paintings Leonardo could never part with: his youthful *Saint John the Baptist*, the *Virgin and Child with Saint Anne* and the *Mona Lisa*. The devilish Salai soon returned to Milan, where he managed the vineyard Leonardo had been given when he painted *The Last Supper*.

The young French King had just turned twenty-two and he gave Leonardo more than just a beautiful residence and a comfortable stipend — he gave him peace. There were still fun festivities to organise and explorations at designing the perfect city, but there was no one pestering and bullying Leo to paint. Francis adored Leonardo, and was content to spend hours simply talking. In these last years Leonardo became regarded as the wise sage and philosopher that he had been modelling himself on in Rome. Francis was as fascinated with the pursuit of knowledge as Leonardo, and the King would go on to become the epitome of the Renaissance ruler.

Tell me
was anything
ever done ...
tell me.
Tell me.
Tell me if ever
I did a thing ...
tell me if anything
was ever made.

LEONARDO

Leonardo's constant questing and easily diverted mind meant that none of his great studies on anatomy, painting, flight, mechanics or optics were published in his lifetime. As Leonardo aged, he was already anxious that nothing he had done would come to anything, and he would have been horrified to discover what happened over the coming centuries.

For fifty years, Leonardo's heir Francesco Melzi protected his master's life work, but after Melzi died, the various folios became spread across Europe and the world. Some works had been destroyed in Leonardo's time, during the French invasion of Milan in 1499, or in the bonfire of the vanities. Other works were cut up and glued together, lost in library filing mistakes, or separated and sold off. Some pieces were destroyed in the Turin library fires of 1667 and 1669. A century later, in the 1790s, Napoleon declared that all geniuses were French and he hauled thousands of Italian artworks and manuscripts back to France, including many of Leonardo's.

Along the way, many inheritors and curators of Leonardo's manuscripts simply disregarded or forgot about these treasures. Through a cycle of discovery, devotion, inheritance, indifference, theft and destruction, Leonardo's life works were dispersed around the globe.

It is all the more miraculous that today we have more than seven thousand pages of Leonardo's notebooks, along with roughly a dozen finished paintings which are undisputedly by the master's hand. Perhaps there are still amazing discoveries to be unearthed in the vaults and libraries of the world.

In April 1519, Leonardo turned sixty-seven. His health had been slowly deteriorating, with failing eyesight and a possible stroke which paralysed his right hand. Romantic legend has it that King Francis sat by the bedside, only a couple of weeks after Leonardo's birthday, and was cradling the beloved old man in his arms when Leonardo passed away on 2 May 1519.

It's perhaps more appropriate to picture an alternate ending — not only a portrait of Leonardo's well-spent life, his never-ceasing curiosity and his easily distracted mind, but a reminder that Leonardo was a real man doing everyday things too. Somewhere in the household, twenty-eight-year-old Melzi is trying to bring order to Leonardo's copious notes for possible publication. Mathurine the cook has just served supper, and upstairs the master is busily working away on a problem involving the geometry of triangles. Leonardo breaks off from his work, stretches his creaking bones and writes the last thing he will ever write … he must stop work, why? 'Perché la minestra si fredda.'

Because the soup
is getting cold.

LEONARDO

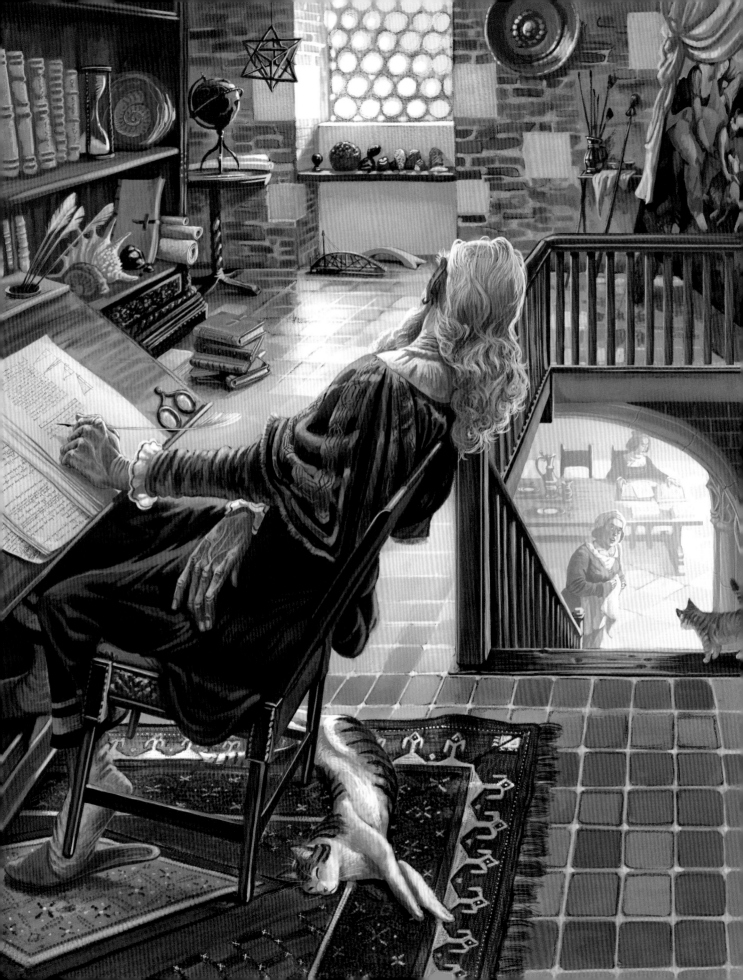

Timeline

1452
Anchiano, Tuscany, Italy, 10.30 p.m., Saturday 15 April. Leonardo di ser Piero da Vinci is born out of wedlock to peasant girl Caterina and city notary Piero da Vinci.

1455 AGE 3
Leonardo's mother marries Accattabriga and gives birth to Leo's half-sister, Piera. Over the next nine years Piera is followed by Maria, Lisabetha, Francesco and Sandra.

1457 AGE 5
Leonardo goes to live in Anchiano with his grandpa Antonio on his father's side.

1468 AGE 16
Leonardo joins Verrocchio's studio in Florence.

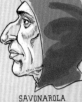

SAVONAROLA

1497
In Florence, Friar Girolamo Savonarola lights his bonfire of the vanities, destroying great artworks including some early works by Leonardo.

1495–98 AGE 43–46
Leonardo paints *The Last Supper* in the chapel of Santa Maria delle Grazie in Milan.

1493 AGE 41
In November, Leonardo unveils his full-size clay model for the bronze horse, to universal acclaim.

1490 AGE 38
Ten-year-old Salai joins Leonardo's household. Leonardo restarts serious work on the great bronze horse.

1498 AGE 46
Leonardo designs flying machines.

1499 AGE 47
Milan is invaded by the French. Leonardo flees the city and his colossal clay horse is destroyed.

1500 AGE 48
Returns to Florence and works on anatomy studies at the Hospital of Santa Maria Nuova.

1504–05 AGE 52
In Florence, Michelangelo's *David* is completed. Leonardo battles with the younger artist, with each man painting competing murals in the city's town hall. Leonardo begins painting the *Mona Lisa*.

1501 AGE 49
Crowds flock to a public display of Leonardo's beautiful cartoon of *The Virgin and Child with Saint Anne*.

1506 AGE 54
Leonardo returns to Milan as offical painter and engineer to King Louis XII of France.

1502 AGE 50
Leonardo is made chief architect and military engineer of Cesare Borgia's army. The campaign takes Leonardo through Tuscany and Romagna, working on maps and engineering fortifications.

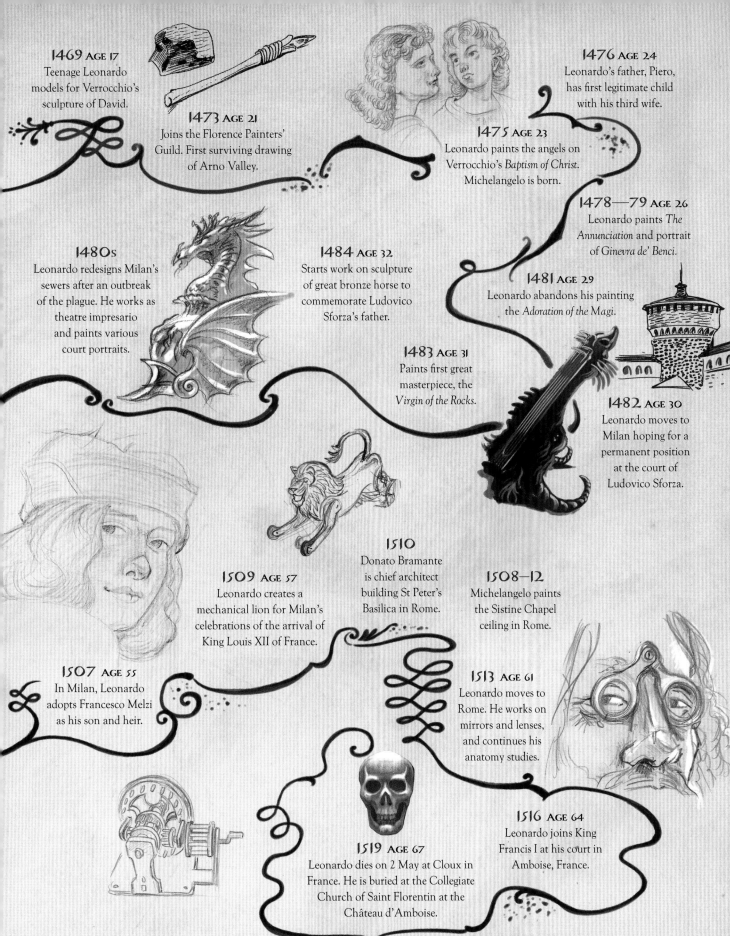

1469 AGE 17
Teenage Leonardo models for Verrocchio's sculpture of David.

1473 AGE 21
Joins the Florence Painters' Guild. First surviving drawing of Arno Valley.

1476 AGE 24
Leonardo's father, Piero, has first legitimate child with his third wife.

1475 AGE 23
Leonardo paints the angels on Verrocchio's *Baptism of Christ*. Michelangelo is born.

1478—79 AGE 26
Leonardo paints *The Annunciation* and portrait of *Ginevra de' Benci*.

1480s
Leonardo redesigns Milan's sewers after an outbreak of the plague. He works as theatre impresario and paints various court portraits.

1484 AGE 32
Starts work on sculpture of great bronze horse to commemorate Ludovico Sforza's father.

1481 AGE 29
Leonardo abandons his painting the *Adoration of the Magi*.

1483 AGE 31
Paints first great masterpiece, the *Virgin of the Rocks*.

1482 AGE 30
Leonardo moves to Milan hoping for a permanent position at the court of Ludovico Sforza.

1510
Donato Bramante is chief architect building St Peter's Basilica in Rome.

1509 AGE 57
Leonardo creates a mechanical lion for Milan's celebrations of the arrival of King Louis XII of France.

1508—12
Michelangelo paints the Sistine Chapel ceiling in Rome.

1507 AGE 55
In Milan, Leonardo adopts Francesco Melzi as his son and heir.

1513 AGE 61
Leonardo moves to Rome. He works on mirrors and lenses, and continues his anatomy studies.

1519 AGE 67
Leonardo dies on 2 May at Cloux in France. He is buried at the Collegiate Church of Saint Florentin at the Château d'Amboise.

1516 AGE 64
Leonardo joins King Francis I at his court in Amboise, France.

True love springs
from the full knowledge of
the thing that one loves.

LEONARDO

Afterword

In 1965, before I was born, a remarkable folio of Leonardo da Vinci's drawings and notes was discovered in the Biblioteca Real in Madrid. They had been filed incorrectly and were thought lost for 252 years. Work progressed on this folio in the early 1970s, and in the following decade these rediscovered treasures were exhibited around the world as *The Unknown Leonardo*. My father happened to see this exhibition in San Fransisco, buying the exhibition books and bringing these wonders back to little old Taupō, New Zealand, and to little old me.

Since my early teens I've vividly imagined Leonardo's world and dreamed of making this book. My intention was to bring his personality to life as only a fellow artist could do, using Leonardo's own quotes to accompany my illustrations. However, be warned that in order to tell Leonardo's life story, I have used some of his quotes completely out of context. For example, the quote describing his 'marvellous invention', the mechanical lion, is actually a quote referring to the human heart. In other sections I have taken Leonardo's words exactly as he intended — although, in his description of the wondrous whale fossil it is impossible to tell if this is fact or a Leonardo fantasy (he was quite adept at writing fiction). In the same way, my paintings are a mix of fact and fantasy. That famous mechanical lion is known only from brief eyewitness descriptions, and I've imagined it constructed by Leonardo's workshop like a stunning suit of armour. Similarly, his adjustable easel, or the scissor-lift (invented to paint *The Battle of Anghiari*), are my imaginings based on other Leonardo drawings of gears and levers. For all the endless mysteries surrounding Leonardo, there are equally moments when we know exactly where he was and what he did. In illustrations like the cranes and lifts for the Florence Duomo, drawings of these inventions are well documented. Likewise the cheap replacement shield his father bought for the peasant really was painted with an arrow through a heart.

This book has been a labour of love, delving into all those thousands of pages of notebooks, where Leonardo presents himself in an almost austere way, and I've tried to find those tiny chinks in his armour where he reveals different parts of his personality. I struggled with the task of depicting his most famous artworks — placing my artwork alongside that of my greatest hero is a competition I'm certain to lose. I've chosen to show Leonardo's paintings from obscure angles — after all, these days the real articles are just a finger click away.

In the end, I'd love you to start your own voyage of discovery so you can distinguish all those little bits of fact and fantasy and to spot the multitude of visual puns and allusions to Leonardo's life and work that I've scattered throughout my paintings. I hope this *Portrait of Leonardo* will spur a true love of Leonardo and make you want to go off and read one of those in–depth doorstop biographies … and when you do, I hope you'll take these pictures with you in your mind and never imagine Leonardo as a grey old Renaissance Gandalf ever again.

About the author

Donovan Bixley is one of New Zealand's most acclaimed picture-book creators, being both an award-winning illustrator and an award-winning author. His numerous accolades include the Russell Clark Illustration Award, the Mallinson Rendel Illustrators Laureate Award, and his books have twice been selected for the International Youth Library's White Raven Award. Donovan's work is nothing if not varied, spanning high-brow to low-brow and every brow in between, from his sublime illustrated biography *Faithfully Mozart*, to the mythical world of Māui, and the ridiculous hi-jinks of feline aviators in his *Flying Furballs* chapter-book series. In 2021 Donovan was made an Officer of the New Zealand Order of Merit for services to children's literature.

When not immersed in the world of picture books, Donovan plays saxophone, piano and guitar. He has performed on stage as Harry Bright in *Mamma Mia*, and Marius in *Les Misérables*, and has worked as a set designer and painter, as well as a character designer and art director for animated series. He lives in Taupō, New Zealand.

Special thanks to Creative New Zealand, the New Zealand Arts Foundation's Mallinson Rendel Illustrators Laureate Award, and to Joy Cowley for the gift of her complete translated editions of Leonardo's notebooks.

This book was created with the assistance of

ARTS COUNCIL OF NEW ZEALAND TOI AOTEAROA

A catalogue record for this book is available
from the National Library of New Zealand

ISBN 978–1–990003–47–9

An Upstart Press Book
Published in 2022 by Upstart Press Ltd
26 Greenpark Road, Penrose
Auckland, New Zealand

Printed by Everbest Printing Co. Ltd., China